The Art of
Calligraphy
Letters

Editorial coordination
Giorgio Ferrero

Graphic design
Maria Cucchi

WS White Star Publishers® is a registered trademark
property of White Star s.r.l.

© 2021 White Star s.r.l.
Piazzale Luigi Cadorna, 6
20123 Milan, Italy
www.whitestar.it

Translation: Megan Bredeson
Editing: Abby Young

Copyright © 2022 by Laura Toffaletti.
Published by Mango Publishing, a division of Mango Publishing
Group, Inc.

Library of Congress Cataloging-in-Publication number:
2022937652
ISBN: (p) 978-1-68481-030-7 (e) 978-1-68481-031-4
BISAC category code ART003000, ART / Techniques /
Calligraphy

The Art of Calligraphy Letters

CREATIVE LETTERING FOR BEGINNERS

LAURA TOFFALETTI

mango
PUBLISHING GROUP

CORAL GABLES

Contents

A B C D E F G H I J K L M N O P Q R S T U V W X Y Z ? !)

Introduction

"You can be great at anything if you practice a lot, so I practice drawing the alphabet." This is how type designer and "alphabetician" Chank Diesel describes his profession. His passion for letters brings the very essence of lettering into immediate focus: doodling, writing, writing by hand, writing often, using various writing instruments and supports, and inventing a graphic creation using very limited means.

Even today, when most typographical characters are designed with computer technology, the creative foundation of the process that has come to define a new font comes from using one's hand—if not on paper, on a simple graphics tablet with a digital pen. By now, it is well-established that the ability to design and write by hand is fundamental to stimulating one's creativity, through the definition of new shapes.

Everyone, or nearly everyone, has the habit of scribbling down words or letters while talking on the phone, writing a shopping list, or writing letters on a folder by hand, for no reason beyond adding decoration.

These all provide excellent preparation for those who have fallen in love with penmanship and the alphabet and wish to come closer to the world of creative hand lettering.

Lettering is the study of how characters are drawn and given a specific shape. One can try to take on various forms of inspiration, often unwitting ones, and turn them into expressive, personal characters. Even if at times these are just sketches, ideas can develop through a search for the most suitable style, one that best expresses what you are seeking to communicate.

Exploring the shape of these letters, and modifying them through trial and error until imperfections are removed—or taken advantage of, heading in an unexpected direction—is an incredibly creative process. It begins at a rather limited starting point: the shape of letters as we have recognized them since learning to write.

This manual will discuss how, beginning with the most traditional forms of the alphabet, you can come up with unique shapes through the use of your creativity and imagination.

Letters can be enlarged, shortened, or lengthened, provided that these variations are implemented within some established thematic criteria and consistencies, maintained within a single style.

So, you can create a stylized alphabet with very long ascenders and descenders, for example, with either very large, or nonexistent, counters. You could come up with letters that are square when they ought to be rounded, or vice versa. You might decide to join letters together with special ligatures or leave them completely detached.

With letters, the variables can be infinite. But, as always, one should be familiar with established norms in order to move beyond them with satisfaction. This is why the first three alphabets shown refer to highly traditional forms of lettering, which you can study and, if you like, use as a starting point to developing your own interpretation. These are roundhand, English cursive, and chancery.

These perfectly illustrate that it is essential to seek and maintain an internal cohesiveness, a rhythm, and a unity throughout the design, in order for it to be balanced and effective.

You will also discover that your letters can easily reach beyond the confines of a sheet of paper and move happily onto other materials, like glass, fabric, rubber, modeling clay, or cardstock. The field of applications is vast, stimulating, and most importantly, highly imaginative.

Tools

MARKERS

A wide range of felt-tip calligraphy tools have long been available at stationery stores and fine art suppliers (1).

These come with various tips (brush, square, or round), which are often combined in the same marker (2, 3). They are very useful for your first exercises, when drafting a layout of the spaces, as well as creating finalized pieces, with letters presented in many colors and shades.

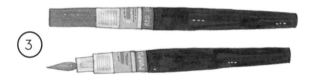

It is also useful to have opaque white calligraphy markers of various widths (4).

In addition to calligraphy markers, markers with a pointed tip (5), rounded tip, or chisel tip, with standard or fluorescent ink, can be used. You can experiment with each of these using unique, inventive strokes.

Permanent ink markers—not just for creative use on paper but also for various other surfaces (6) like glass, metal, ceramic, or fabric (7)—will be very useful as well.

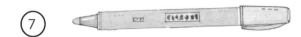

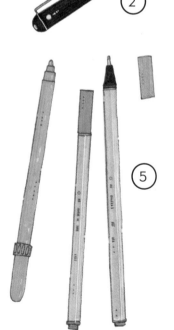

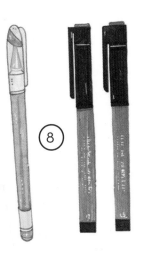

GEL PENS

Gel or glitter pens and markers (8) are often used in the final stages of a project to decorate letters or borders. With these, you can create patterns or dots of light to give letters a lively, jewel-like quality.

It is helpful to have gold and silver pens (9) for small, elegant touches. Brands include Tombow, Pentel, Faber-Castell, and Manuscript.

FOUNTAIN AND PARALLEL PENS

These are very practical because they come with a removable ink cartridge, which can be replaced with many colors other than black. There are pens with broad-edge nibs (also known as square or chisel nibs) of various sizes. Some pens, like the Pilot Parallel Pen (10), have parallel metal layers, which allow for greater precision while making thick and thin strokes. Popular brands include Lamy, Sheaffer, Rotring, and Pilot.

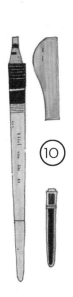

METAL NIBS

Metal nibs can be square (broad-edge) or pointed (11), firm or flexible (soft) (12), and come in straight, elbow, or rounded shapes. You can find them in fine arts supply stores or specialty shops for calligraphy materials. Broad-edge nibs are available from many brands (like Brause, Speedball, Manuscript, and others). Some of the nibs most widely used by calligraphers come from William Mitchell. The company's roundhand dip pen comes with a set of ten nibs, ranging from size 6 (narrowest) to O (broadest).

Elbow and flexible nibs are typically used for cursive writing. Nib flexibility is a personal choice and is determined by various factors. Nibs can be found in softer or firmer models, and you might make your selection, for example, according to what writing best suits the heaviness of your hand.

You will find some information about using broad-edge and flexible nibs in the "Exercises" section.

TRIANGLES AND RULERS (STRAIGHT EDGES)

For an aspiring type designer, 90°-45°-45° and 30°-60°-90° triangles (13), straight edges of various lengths (14), flexible rulers (15), and a compass (16) are must-have pieces of equipment.

These are used for drawing guidelines, to mark out the slope of your letters and angle of your pen, and to create a layout to contain the written text.

INK

Ink (17) is mostly used with flexible and broad-edge nibs. Very often, however, people opt immediately for felt-tip pens and markers as a practical measure, even if metal nibs guarantee a better definition of stroke.

It is better to use black ink for practice; when it comes to creating finished designs, there are many alluring colors on the market, including gold, silver, and white.

PAPER AND OTHER MEDIA

A good 60 g/m² (16 lb.) sketch paper will do very well to start. It holds ink well and has a transparency that allows you to experiment.

Gradually, as you become more comfortable with these tools and making strokes, you can move on to high-quality papers like those from Amalfi, Fabriano, or Magnani—cotton paper with fine, uniform grain.

You will find that you can write on many surfaces other than paper, like glass, fabric, ceramic, plastic, and leather. Before you begin to write, on paper or any other material, it is best to test your writing instruments on a sample, or somewhere that is not readily visible.

Make sure you also have these:

(18) HB pencil

(19) Soft eraser

(20) Eraser refill

(21) Pen holder for metal nibs

(22) Pointed metal nibs

(23) Broad-edge metal nibs

(24) Scotch tape

(25) Masking tape

(26) Capillary pens and markers

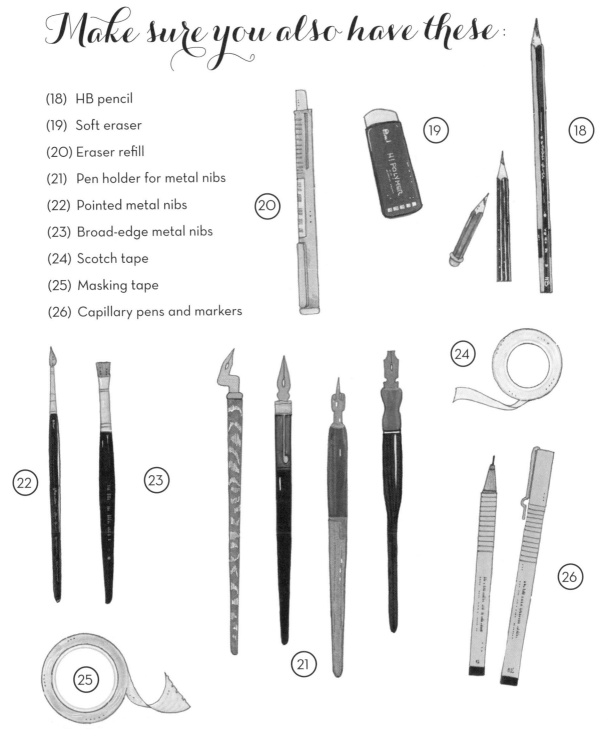

Glossary

Alphabet – The word comes from the names of the first two letters in the Greek alphabet: *alpha* and *beta*. An alphabet is a series of letters arranged in an ordered sequence.

Arch / Shoulder – The curved top or bottom of a letter.

Ascending letters – The letters with a stem that goes above the x-height: b, d, f, h, k, l, t.

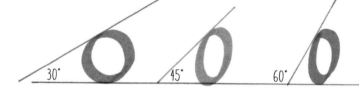

PEN ANGLE

Basic stem – A stroke with the same thickness throughout, i.e., a full-pressure stroke.

ARCH / SHOULDER

Body height – The height of a letter.

Calligraphy – The art of forming beautiful characters with harmonious proportions: the word comes from two Greek words joined together: *kalòs* (beauty) and *graphein* (write).

Character / Glyph – A symbol that is given a meaning: in this case, the shape of the letters in an alphabet.

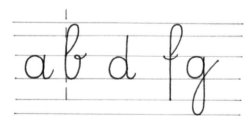

UPRIGHT OR VERTICAL CHARACTERS

OBLIQUE OR SLANTING CHARACTERS

Counter – The enclosed round space or eyelet in a letter.

Descending letters – Letters with a tail that goes below the baseline: g, j, p, q, y.

Ductus – The number and sequence of strokes that make up a letter.

Eurythmy – The uniform and constant appearance of each part of a piece of calligraphy.

Guidelines or alignment lines – The lines that determine the height of lowercase and uppercase letters. Guidelines are essential for establishing the height of the letters and their various strokes. They can be delineated by measuring with a ruler or, when writing with a broad-edge nib, using the nib width.

Interlinear space – The vertical space between two lines of writing. It is the maximum stroke width of a nib.

Letters – The characters in an alphabet; each represents a sound.

Ligature – A link between two letters using one or more strokes, or a combination of multiple characters into a single glyph.

DIFFERENT KINDS OF SERIFS

INTERLINEAR SPACE

Margin – The upper, lower, or lateral space within which a page of writing is composed. Well-chosen margins create a balanced page.

Oblique or slanting character – One that slants varying degrees to the right.

Parallelism – The consistent slant of the strokes in an alphabet.

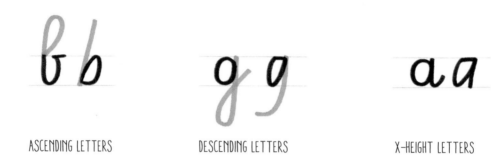

ASCENDING LETTERS DESCENDING LETTERS X-HEIGHT LETTERS

Pen angle – The angle at which the nib must be positioned on the paper to produce the strokes of the letters correctly; each calligraphy alphabet has its own pen angle.

Pen or nib width – Serves to determine the height of the letters; each calligraphy script uses a specific nib width.

GUIDELINES OR ALIGNMENT LINES

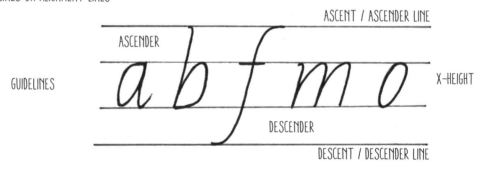

Radicals or basic forms – The letters, or parts of a letter, that when combined, form all the letters of the alphabet. Each alphabet has its own radical letters, such as "o," "a," or lowercase "n."

Serif – Decorative element on the final strokes of certain characters.

Slope – The slant of a letter, which may lean more or less to the right.

Space – The horizontal distance between letters and words.

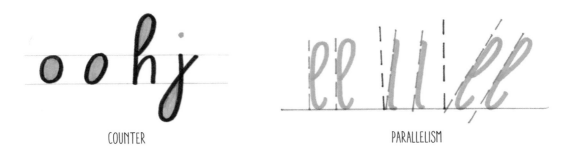

COUNTER PARALLELISM

Spacing – The distance between letters or words. The spacing between letters is not determined by precise rules, but there are some general precautions. For instance, the distance between vertical letters (e.g., an "i" and an "l") constitutes the greatest distance within a word, while two round letters (e.g., a "b" and a "q") instead are placed as close to each other as possible. The space between words in typography corresponds to the width of the letter "i," and in calligraphy to that of the letter "n."

Straight or vertical character – One that is perpendicular to the guidelines.

Stroke – A line made with a single movement of the pen.

Swash / Flourish – The extension of a letter's terminal or initial stroke with a grand movement of the pen.

X-height letters – The letters that sit between the baseline and the median: a, c, e, i, m, n, o, r, s, u, v, w, x, and z.

SWASH / FLOURISH

OTHER WORDS TO KNOW:

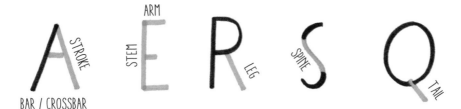

Alphabets

Three examples are offered in this section based on the essential shapes of three classic lettering styles: **chancery**, **roundhand**, and **English cursive**.

Chancery is one of the oldest extant lettering styles. The italic version of the script was introduced by Ludovico degli Arrighi of Vicenza in 1522. It has been rediscovered in recent years for its dynamic style and flexibility, and it is very often used in advertising, publishing, and fashion.

The **cursive** included here was developed in 18th-century England and is a highly slanted, formal cursive.

The **roundhand** (Italian roundhand) shown here was taught in Italian schools until the 1960s, with the use of nib and ink.

All these characters stand out for being extremely legible, boasting a clear shape. This precision allows us to explore various possibilities through creative variations, and they lend themselves very easily to making highly original or personal projects.

The scripts and typefaces shown in this section are written with a fine-point marker: guidelines defining the height of characters in each alphabet are shown with measurements in inches. The measurements are outlined several times on the writing exercise sheet with a ruler, showing length and height, taking line spacing into account.

In classical calligraphy, chancery is actually written with a broad-edge nib, cursive with an elbow nib, and roundhand with both, using ink in all three cases.

Another important model in the study of hand lettering is the majuscule (uppercase) typeface inspired by Roman capital shapes: a model of harmony and precision, based

on a solid geometric structure. It appeared in 113 CE in an inscription at the base of the Column of Trajan in Rome.

We are seeking, firstly, to become familiar with uncommon, long-lost forms of writing, to recover a forgotten manual skill. Once you have experienced it, you may be surprised at the pleasure that can come from making a composition in text using proportionate, harmonious letters in vibrant colors.

To get started:

1. Assemble all the right TOOLS and a good sketch pad.
2. Select an alphabet and examine the patterns carefully: the letters' PROPORTIONS, slope, and shape.
3. Draw the GUIDELINES in pencil each time, even if it may seem superfluous. This is a fundamental step toward obtaining a good result.
4. Train your hand to hold the pen at a fixed ANGLE.
5. Don't become complacent and keep practicing: it would be ideal to write for a few minutes every day.
6. Regularly compare what you have written with the examples provided in order to note differences or mistakes.

Happy writing!

Roundhand

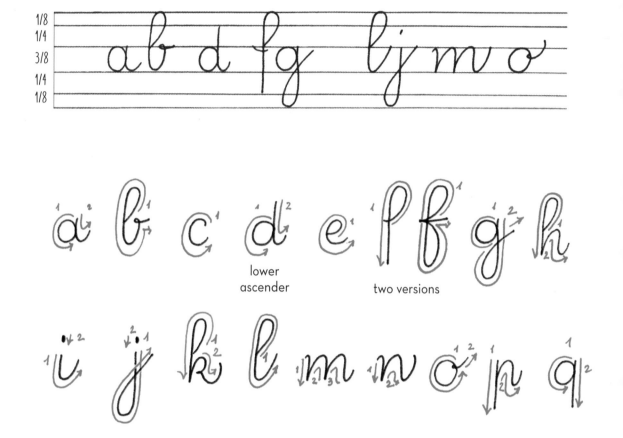

lower
ascender

two versions

lower
ascender

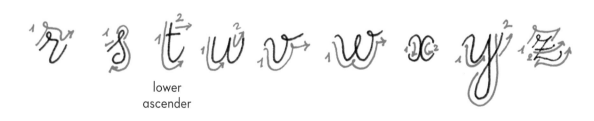

This version of roundhand script was taught for years in Italian schools, where calligraphy was an official school subject into the early 1960s.

Its character is simple, straight, and smooth, with wide, round counters.

With its youthful feel, it is well-suited to projects dedicated to children, the birth of a new baby, and birthdays.

Write all the letters of the alphabet, connecting each of them as in the example.

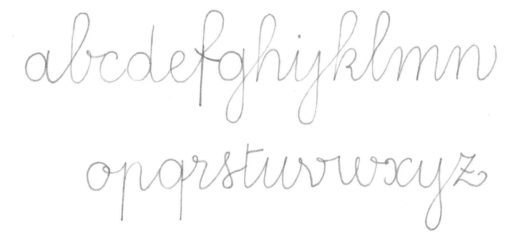

Write all the letters of the alphabet and connect them, adding breadth to strokes using the same fine-point marker.

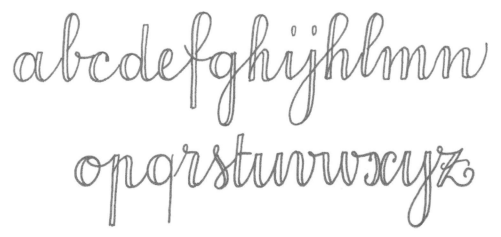

NOTE: As with all alphabet designs, thicknesses must be consistent in order to maintain a standard of order and regularity between letters.

The uppercase letters in roundhand are broad and often written with a single stroke of the pen. Before you begin to write, you can follow along with the strokes, holding your pen suspended above the letters in order to get a feel for the movements involved.

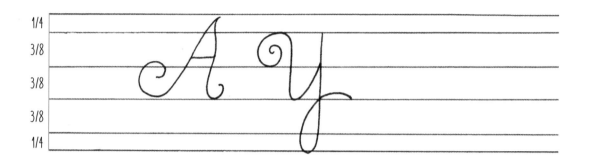

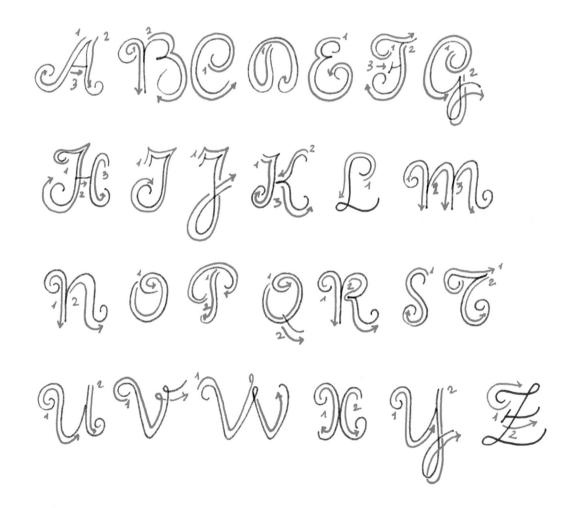

Uppercase letters are kept separate from lowercase, rather than connected.

Now try to write out the letters, marking out thicker places.

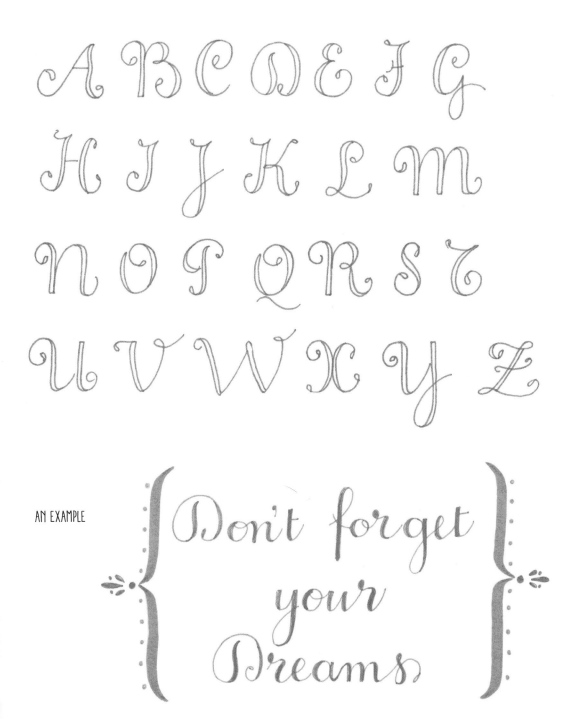

AN EXAMPLE

English Cursive

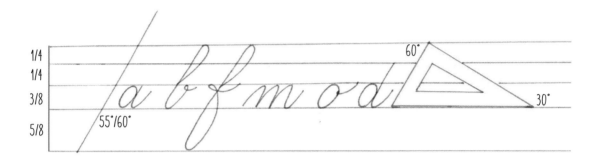

1/4	
1/4	
3/8	60°
5/8	30°

55°/60°

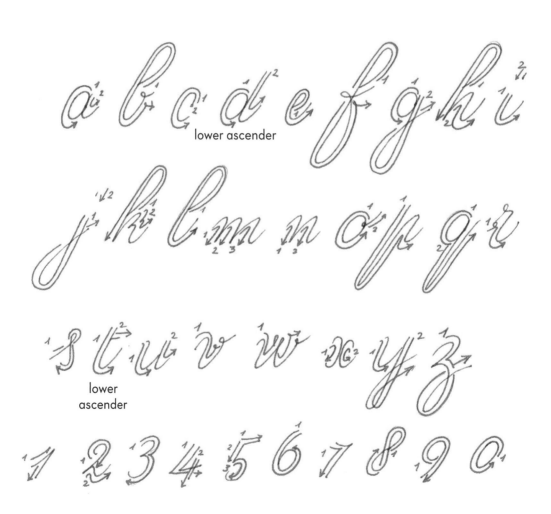

lower ascender

lower
ascender

This form of cursive originated in 18th-century England, where it was used both in commercial settings and for personal writing.

It is characterized by its letters' narrow, oval shaping, its characters' emphatic rightward slant (55–60 degrees), and, when written with an elbow nib, for the marked difference between its thin and thick strokes.

Its traditional format is mostly utilized to write highly formal, elegant text.

Now try to write the entire alphabet, joining letters as illustrated. Take care not to lose the slant of your writing and to maintain parallelism between letters.

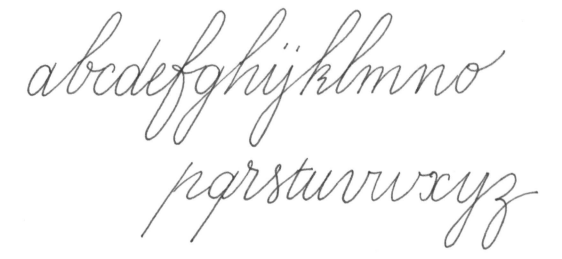

Write the alphabet out again, with the letters connected, adding thick strokes.

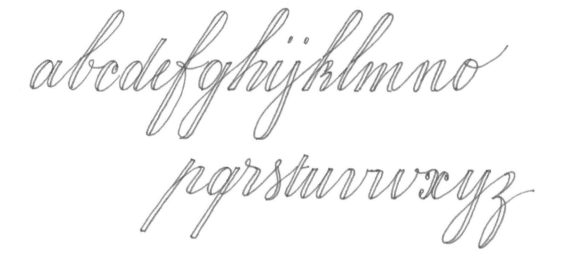

5/8

3/8

As in roundhand, the capital letters in English cursive are generously proportioned. Before you begin writing, note carefully where strokes begin and end.

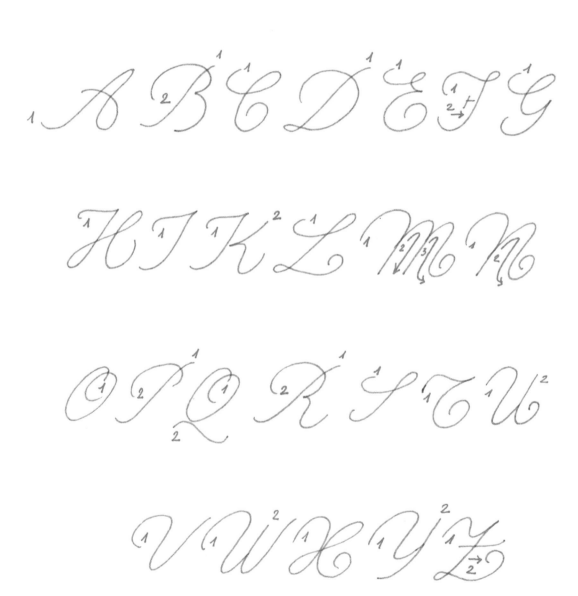

Now write out the uppercase letters, adding thick strokes. Again, take note of their slant.

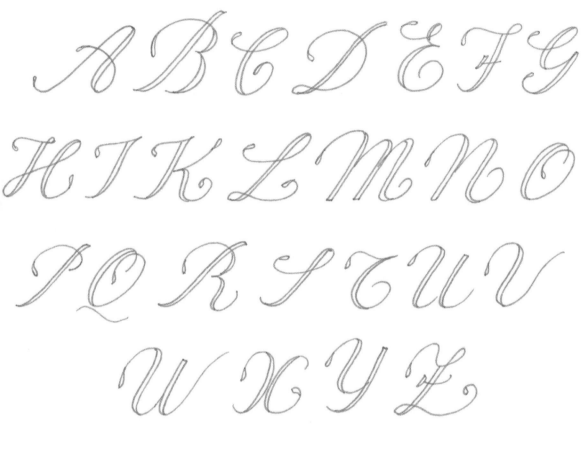

AN EXAMPLE

if you are not

sensitive

you are not

Sublime

Chancery

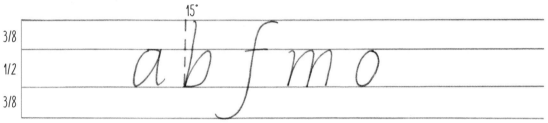

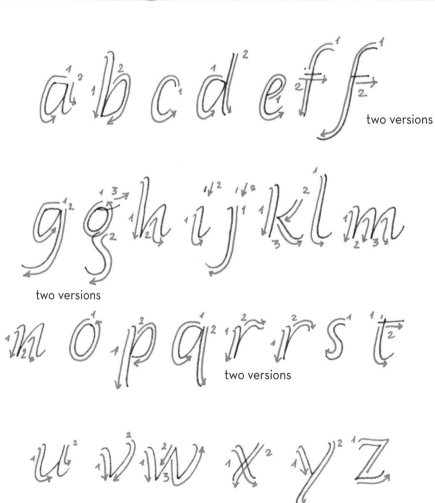

two versions

two versions

two versions

Chancery cursive, or italic, which this alphabet is inspired by, is one of the oldest extant typefaces, based on a modification of chancery hand script. Today, the characteristics that determined its success in 1522 are still more or less the same. The original form was written with a broad-edge pen nib and a pen slant of 45 degrees.

The characters of the cursive script are gently sloped to the right (about 15 degrees), with oval letters that begin at a right angle, with the stroke returning to form an almond shape.

The style of chancery shown here has no ligatures between letters, but as illustrated on later pages, it is possible to connect them.

Write out the full alphabet, maintaining a rightward slope.

abcdeffgghijklm

nopqrrstuvwxyz

Write out the alphabet again, adding thickness to strokes, as in the example shown.

abcdeffgghijklm

nopqrrstuvwxyz

Uppercase letters, like the rest of the alphabet, are narrow and slender: do not exaggerate the roundness of the curved strokes.

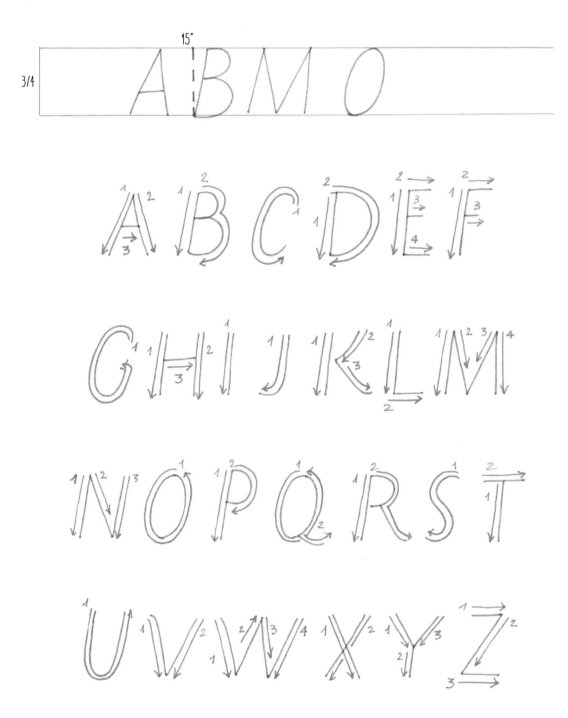

Trace the breadth of the strokes, observing the proportions and spacing between letters.

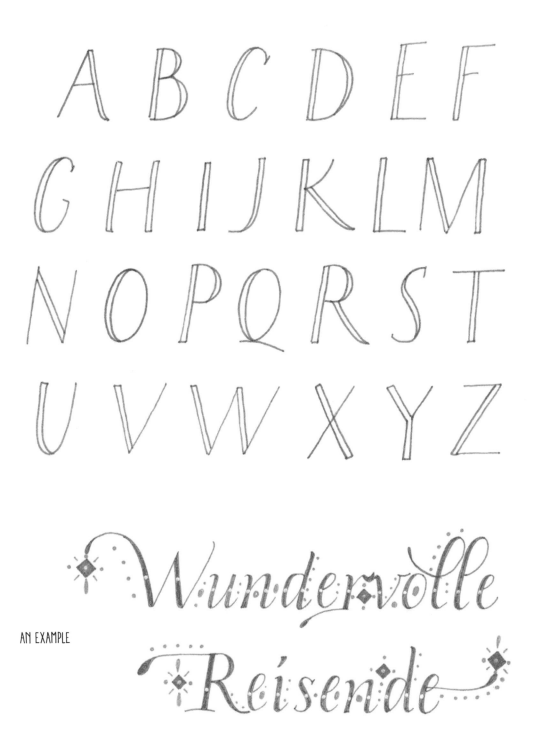

AN EXAMPLE

Majuscules

The following is based on one of the greatest examples of typeface in the history of lettering: Roman square capitals, on the inscription at the base of the Column of Trajan in Rome (113 CE). Based on a solid, geometric structure, it is a fundamental model for its perfection and clarity of form.

THE PROPORTIONS OF ROMAN SQUARE CAPITALS

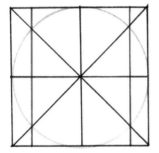

ROUND AND NORMAL LETTERS

NARROW LETTERS

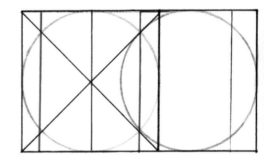

WIDE LETTERS

The letters are divided into:
Round letters: C, D, G, O and Q occupy the entire grid
Normal letters: A, H, N, T, U, V, X, Y, Z occupy three-quarters of the grid
Narrow letters: B, E, F, I, J, K, L, P, R, S occupy half of the grid
Wide letters: M, W are the width of the grid

ROUND LETTERS

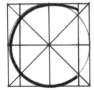
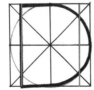
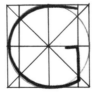
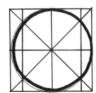
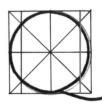

NORMAL LETTERS

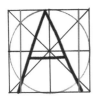 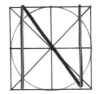 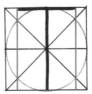 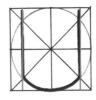

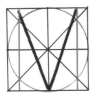

NARROW LETTERS

 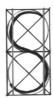

WIDE LETTERS

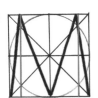 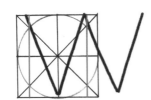

NORMAL LETTERS

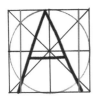 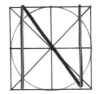 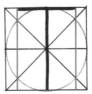 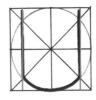

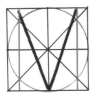

NARROW LETTERS

 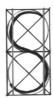

WIDE LETTERS

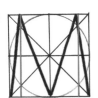 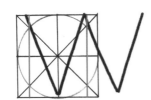

To begin, trace a series of guidelines onto two sheets of paper using the broad-tip cal-ligraphy marker. On the first, place a 30°-60°-90° triangle onto the baseline, and using a pencil, draw a series of straight lines at a 30-degree slant with a distance of 1 in. (⅔ cm) between each other.

Do the same thing with the second sheet, this time using a 90°-45°-45° triangle.

Write out the alphabet in pencil on the 30-degree sheet and the 45-degree sheet.

PEN ANGLE

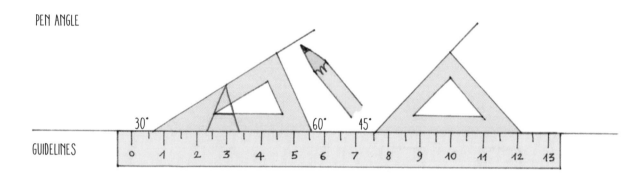

GUIDELINES

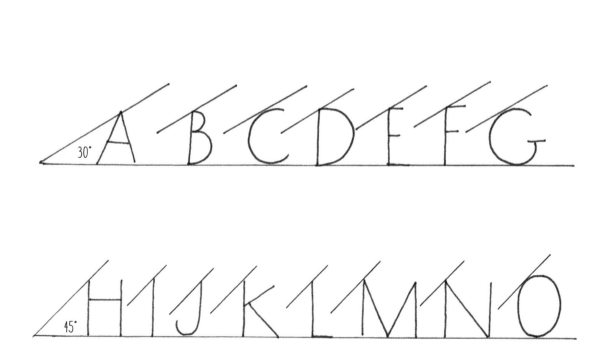

Now try to add thicker lines with the broad tip of the marker. Position the tip of the marker as shown in the illustration, and make a confident stroke, keeping the angle of the pen constant, even as you make curved strokes.

First write the alphabet at a 30-degree angle, then write it at a 45-degree angle. Serifs are made by drawing a small triangle with a fine-point marker on a letter's terminal stroke, then filling it with ink.

SERIFS

30°

A B C D E F
G H I J K L M
N O P Q R S T
U V W X Y Z

Referencing the essential structure of Roman capitals, try to write the letters and modify them slightly, making the letters a little narrower or a little wider, trying out various thicknesses.

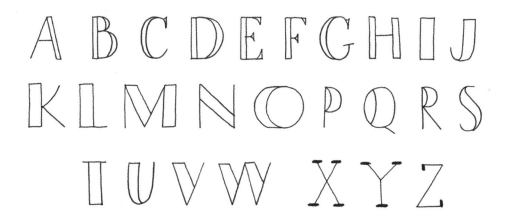

33

Once you have had some experience with the letters and the width of their stroke, you can begin to create some decorative motifs, using the same for the entire alphabet or something different for each letter. You will have to try them out many times to achieve a satisfying and harmonious result.

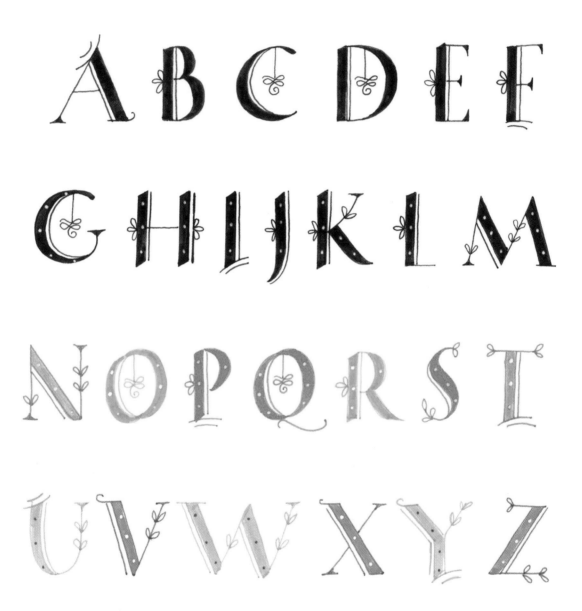

Some more ideas for embellishing letters: You can prepare a series of motifs in pencil that can be used inside the edges with the fine edge of your calligraphy marker tip. You can fully indulge in shapes and colors while keeping spaces clearly defined. These should be quite small, to avoid a messy end result.

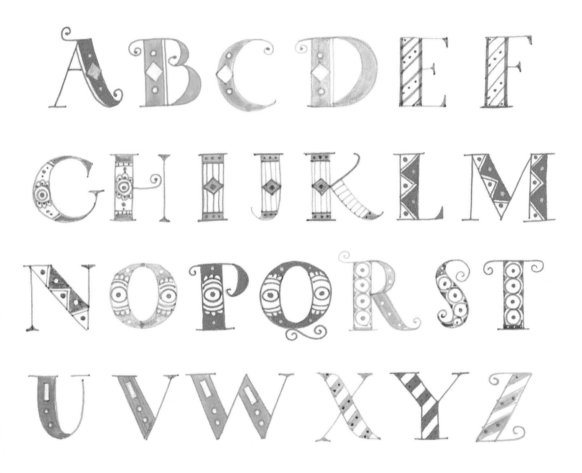

SOME EXAMPLES OF DECORATION

With capital letters and a few broad-tip markers, you can create interesting effects. Here, curved and rounded strokes are made with the tip of the marker, while the vertical and oblique strokes are created touching the full width of the broad tip to paper.

ABCDEFGHI
JKLMNOPQR
STUVWXYZ

Another majuscule alphabet with a unique decoration.

ABCDEFGHI
JKLMNOPQR
STUVWXYZ

Here, the marker has a defect that creates an interesting pattern. Sometimes the most original ideas come from random factors, such as, in this instance, a pen that is considered unusable.

ABCDEFGHI
JKLMNOPQR
STUVWXYZ

A very delicate stroke for this bold color.

ABCDEFGHI
JKLMNOPQR
STUVWXYZ

Minuscules

It is also possible to attempt variations on lowercase roundhand letters. While simple, they can still make your writing more interesting.

For example, strokes can be made thicker or thinner with a fine felt tip, making the letter blacker and bolder, or lighter.

a a a a b b b b m m m n n n o o o

Ligatures can also be changed; they can be lengthened rhythmically, while keeping the shape of the letter consistent. Ligatures can also be created without any breaks, to create another simple, distinctive pattern.

abcdefghijklmno abc defg hijkl mno

Now try widening the letters' upper counters: remember that as you continue to experiment, it is best to make simple changes and gradually evaluate whether or not further emphasis is needed.

abcdefghijklmno

Beginning with a brief sentence written in standard roundhand, apply one of the modifications that you tested. Begin by writing simply, without any broad strokes.

la vie en rose

la vie en rose

la vie en rose

The long lines in English cursive are incredibly tempting, but variations must be well calibrated so you are able to maintain a fluid line without any trouble.

Here, try creating strokes of various widths, simple or elongated ligatures, and adding small decorations to strokes.

a a a b b b m m m o o o

abcdefghijklmno a bcdefg hij klm

Once you have experimented with broad strokes and ligatures, create a few groups of letters, joining them with elongated ligatures, with some small decorations. Make sure that the white spaces between these groups of letters are balanced.

merci beaucoup

merci beaucoup

mer cibeau coup

Lowercase chancery letters can be easily adapted for your most imaginative creative needs. You will note this as you gain more experience with writing this script.

As you did in the previous exercises, work on introducing broad strokes, ligatures, and small variations to the letters. The ligatures in this illustration of chancery lettering reference the ligatures in English cursive.

a a a b b b m m m o o o

UNJOINED LETTERS

abcdefghijklmno

JOINED LETTERS

abcdefghijklmno

LIGATURE VARIATIONS

a bcd efg hij k

AN EXAMPLE

un beso un bes o

dame un besito

Here is an exercise for learning to keep the shape of the letters consistent: Draw a curved guideline and write the entire alphabet along it with the letters joined together, attempting to respect the height, slope, and shape of the letters. Do several tests with a pencil and markers. Do not rush yourself, write at your own pace at first.

Repeat the exercise, gradually increasing your writing speed without losing the rhythm. Note how less controlled writing can influence the shape of counters, ascenders, and descenders.

Brush Calligraphy

5/8	
3/4	*a f m*
5/8	

a b c d e f g
h i j k l m n
o p q r s t u
v w x y z
1 2 3 4 5
6 7 8 9 0

As indicated in its name, this is a style of writing that uses a pen with a brush tip. As in English cursive, its distinguishing characteristic is the alternation of thick and thin strokes obtained by exerting more or less pressure on the pen. This style is much loved by those who wish to represent the immediacy of gesture and a "freshness" in the writing. Brush shapes are many and varied; to start, try to write out a lowercase alphabet inspired by English cursive. The slope of writing in this example is less pronounced than in the original cursive, yet its slant to the right is still evident.

The capital letters of English cursive have been simplified here. Once you have acquired a good mastery of the pen, the capitals can actually be enriched with highly complex flourishes as well, many examples of which can be found in samples from history and formal calligraphy manuals.

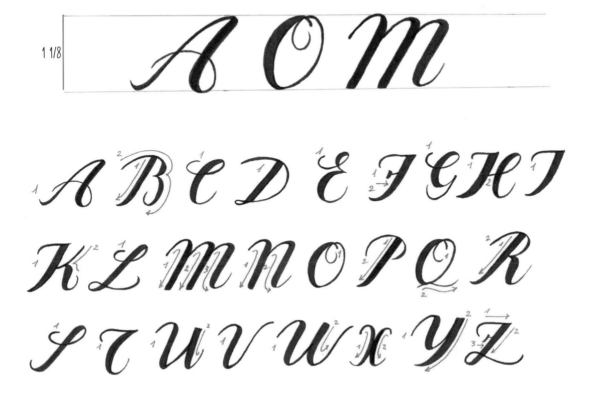

The sentence to be written here is a classic calligraphy exercise: "The quick brown fox jumps over the lazy dog" contains every letter of the alphabet and can be a useful alternative when one is tired of continually writing the alphabet (...alphabetically).

the quick brown fox jumps over the lazy dog

Another script that is often written with a brush derives from the shape of chancery lettering; try writing these lowercase letters using this ductus.

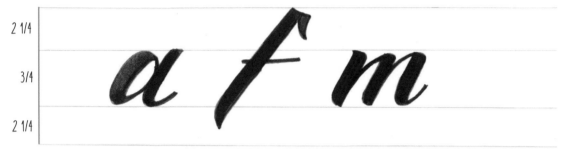

2 1/4

3/4

2 1/4

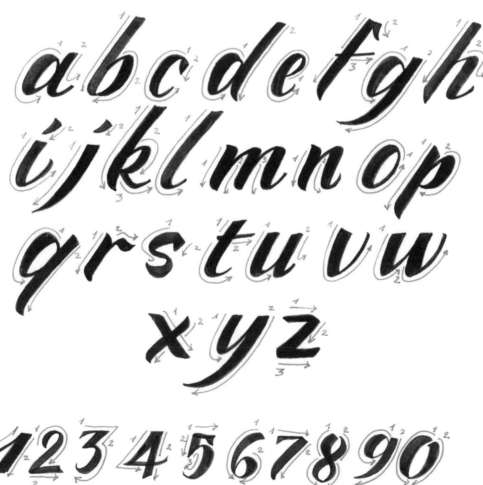

Now write out the capital letters, remembering to maintain the parallelism between letters and the narrow shape characteristic of chancery.

1 1/8

A O M

A B C D E

F G H I J K L

M N O P Q R

S T U V W

X Y Z

Write out "The quick brown fox..." again with the shapes you have practiced. Compare the two styles of writing after you have done these exercises to verify that characteristics between one and the other can be easily recognized.

the quick
brown fox
jumps
over the
lazy dog

Calligrams

A calligram is a very old form of decoration made from letters and words. From ancient Greece to illuminated manuscripts, to the poet Apollinaire, to the Futurists, the calligram has spanned the entire history of art, remaining in the background yet constituting one of the most original models of decoration using letters. Nowadays, it is often used in advertising, in graphics, to design a unique tattoo, and in many diverse environments.

A calligram consists of a short text in which the writer draws the subject of the text using words: if a ship is being described, the letters and words will be arranged on paper to form the image of a ship.

The writing becomes flexible, in order to accommodate the shape: it can be straight, slanted, narrow, or wide, all according to how the chosen subject can be best represented.

To get started:

Draw two guidelines, then write the sentence "The quick brown fox…" on each guideline in lowercase chancery, without any spaces between the words. Try to make sure that the sentences are the same length.

thequickbrownfoxjumpsoverthelazydog
thequickbrownfoxjumpsoverthelazydog

Draw two parallel wavy guidelines and repeat the exercise.

thequickbrownfoxjumpsoverthelazydog
thequickbrownfoxjumpsoverthelazydog

Draw two wavy guidelines that mirror each other; repeat the exercise. Practice with different wave shapes, some more dramatic and some more subtle.

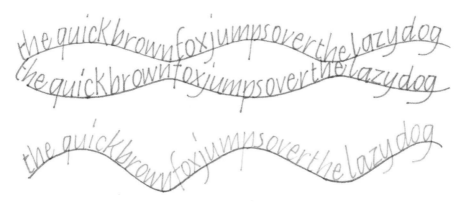

Draw two wavy lines that are neither parallel nor specular: this time, fill the space between the two lines by adapting the shape of the letters to the curves.

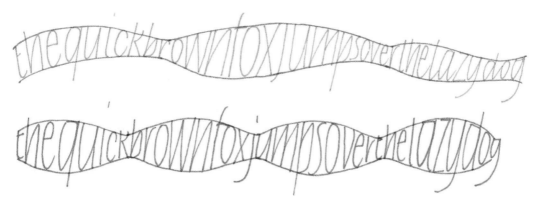

Draw two converging and diverging lines: fill the growing and shrinking space with letters.

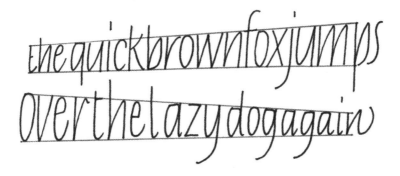

To create a calligram, one must begin with a simple template, a design with no jagged, indented areas that is not excessively small.

Here, a poem was chosen that lends itself very well to an easy but effective illustration: "Arboles" by Federico Garcia Lorca.

1. Write the text with a chosen alphabet, in this case chancery, and measure the length of the individual lines with a ruler.
2. With a pencil, sketch the shape of the tree you wish to illustrate; write a first draft of the text, and make it look compact, without excessive spaces in the design. When you are satisfied with the result, make a stylized shape, again using a pencil and ruler, with consistently spaced guidelines.

3. It will take several tries to ensure that the lines of the poem you have written and measured out can be placed on the guidelines symmetrically on the trunk of the tree. Pay attention to the ascenders and descenders.

4. Once you have reached the desired shape, write out the leafy top of the tree-poem with a green fine-tip marker, adding thick lines to the strokes and small decorative elements to balance out any gaps.

5. Then make the tree trunk, writing with very small letters, not adding any thick strokes to them.

6. You may continue working with the design, adding land, clouds, stars, or other decorative elements, while always highlighting the main subject.

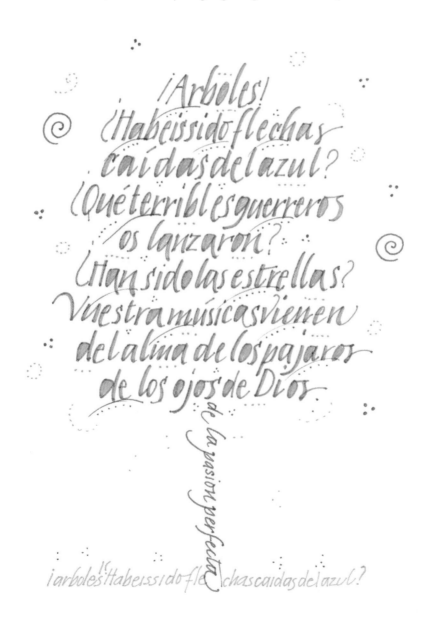

Creating or looking for calligram designs is one of the most entertaining aspects of this artform. Taking inspiration from photographs or illustrations (whether old or contemporary), you can either draw the designs yourself or use the images, tracing them in pencil on the sheet of paper you are using to prepare your outline sketch.

Here are two schemes, for two different poems: one is "Goodbye, Brother Sea" by Nazim Hikmet (Italian translation), the other is from Charles Baudelaire's *Les Fleurs du mal*. The first, taken from a fourteenth- or fifteenth-century calligram written in Sanskrit, refers to the shape of a shell; the text is written in capital letters, following the curvature of the lines. Photocopy this design and practice writing out the verses

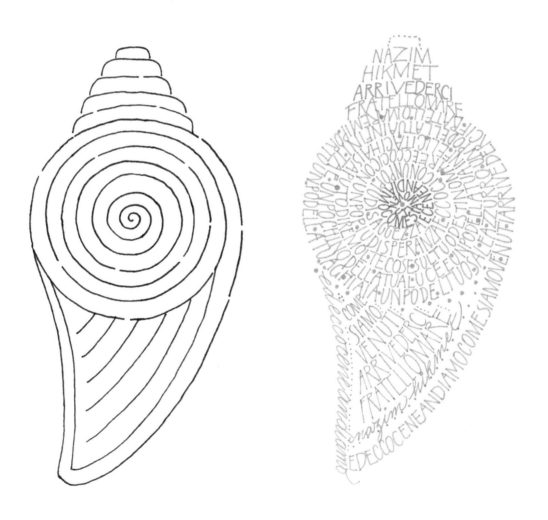

"GOODBYE, BROTHER SEA" – NAZIM HIKMET

a few times, taking care to keep the letters perpendicular to the lines. You can lastly fill in any excess spaces with different colored dots and sign the design using a different style of script. The second, dedicated to a verse in Baudelaire's "The Voyage," could only be a ship, taken from the design of an Austrian calligram from 1749. For this calligram, an extremely pliable English cursive was employed. The ship and the waves are written with slightly wider letters, while the sails are done with a very fine-point nib so as not to weigh down the overall image.

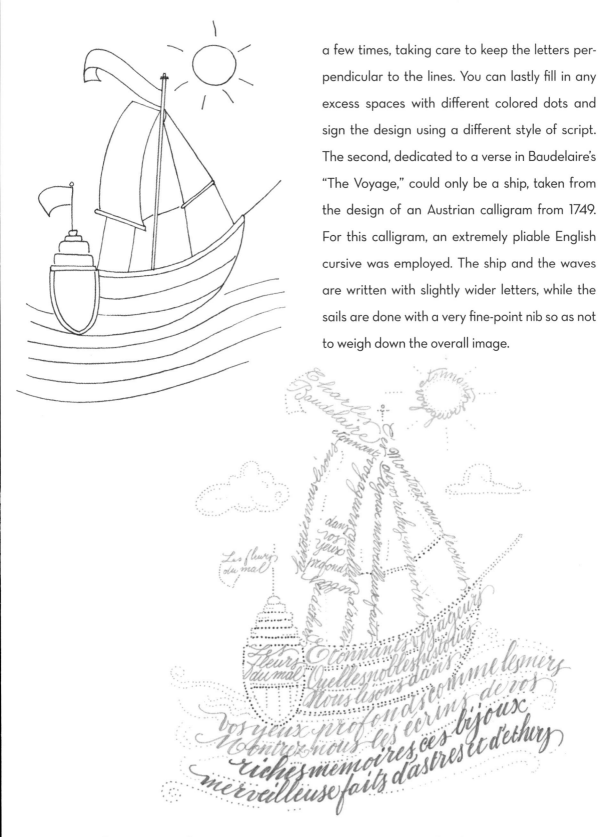

"THE VOYAGE" FROM *LES FLEURS DU MAL* – CHARLES BAUDELAIRE

Pictured here are a rose, inspired by an 18th-century calligram, and a tree with its leaves depicted in wavy lines, where you can write the text of your choice. The rose is composed of everyday English cursive writing, enhanced with small strokes made with a pointed nib, and capitals repeating the word "ROSA." The text used is from *Unica Rosa* by the Italian singer Ivano Fossati.

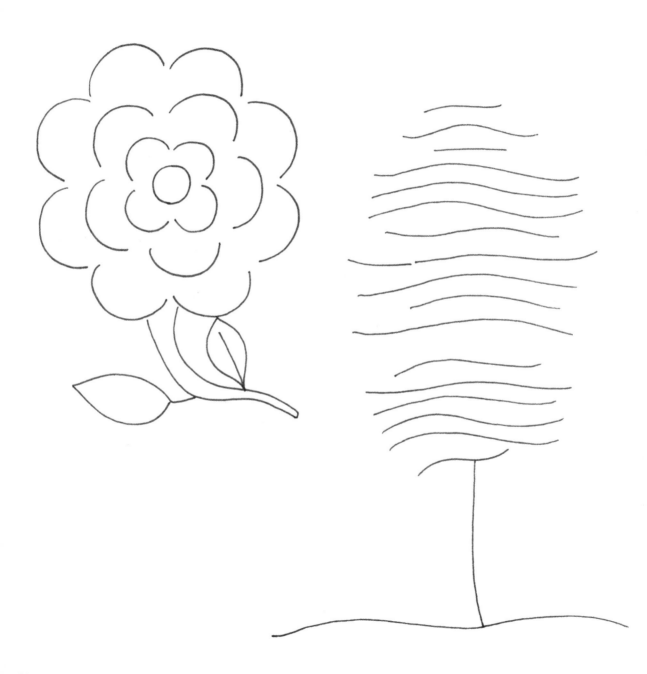

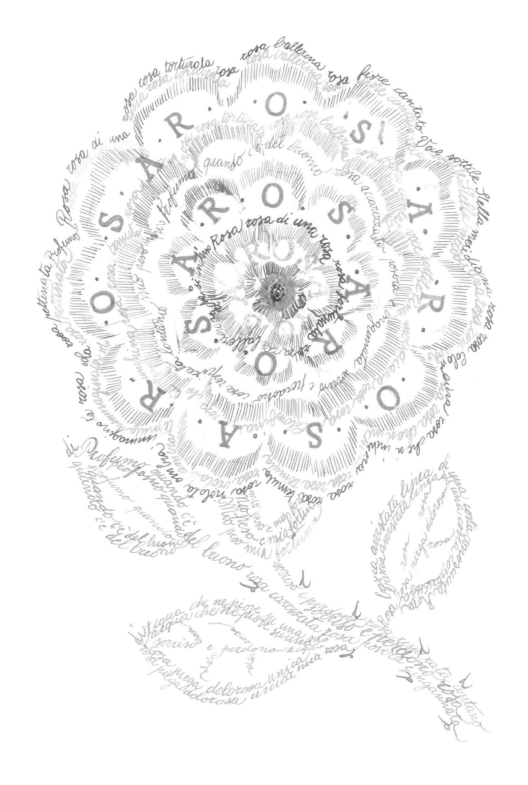

Rosa rosa di una rosa rosa fortunata

Decorations

In hand-lettered text compositions, decorations play a significant role and a very fun one. They can be executed in a thousand different ways by assessing the most suitable style and instrument for each.

Compositions can be made with fine-, medium-, or broad-tip markers and nibs. They can be either monochromatic or colorful, either rigorous or freer and more expressive.

It is necessary in this case to make several sketches in pencil before a final result is reached. Remember to also test a selection of colors when drafting in order to be certain of your final version.

Below is a small selection of motifs that can be used in your projects.

1. Simple, straight lines, either single or parallel, of varying thicknesses.
2. Lines adorned with little leaves, straight, wavy, or curled at the ends.
3. Vertical decorative elements with subtle floral motifs.
4. Curled accents and scrolls, which require some preparatory sketches for them to be symmetrical:
 A. Sketch your curled design.
 B. Measure its length and height with a ruler, then draw a small grid with double the length of your sketch measurements and mark out the axis of symmetry with a dashed line (4).
 C. Draw a scroll inside the grid, and then a second, so that they are mirroring each other across the central axis, paying special attention to the direction of the coils. After some practice tests, draw the scrolls freehand.
5. Brackets of different thicknesses.

1. Train yourself to draw freehand spirals, drawing in a small square layout in pencil. Starting from the center of the square, draw your spiral so that the spacing between the curved lines is consistent. Once you have the feeling for it, try outside the square. The spiral is a highly decorative element, and it can be composed in creative and original ways.

2. Another useful exercise is drawing a corkscrew shape in pencil. Here it is important to keep its loops regular, with the same height and a consistent rhythm. Practice by drawing two guidelines and then drawing a coil between them in a single stroke.

3. More complex flourishes require the same approach at the beginning as curled accents and scrolls. From a freehand sketch, find your desired proportions and practice inside a grid to maintain the regularity of the lines and scrolls.
 In the illustration provided, the loops are regular, and oblique lines are parallel to each other. You can create flourishes that are symmetrical or not. The most important thing is to maintain a shape that is balanced.

4. Sometimes, a single element is enough to enhance the entire design.
 The opposite page provides some examples of small decorations that can be made either with thin strokes of a pen or nibs using colored inks.

When discussing decorations, borders of various shapes and sizes cannot be overlooked, whether very simple or highly elaborate.

1. With a compass, draw a circle of the desired size in pencil, then retrace it by hand with a fine-tip marker. Along the entire circumference, add small rounded or pointed leaves (both types illustrated in the example below), regularly spaced groups of leaflets, or floral or diamond motifs at the top, bottom, and sides of the circle. You can use the same decorative elements on a rectangular frame with rounded corners.

2. A subtle arc can also enrich a composition: draw it in pencil with your compass, adding finishing touches with fine-point markers. Arcs can be placed above and below a written text. Hearts and other decorations placed within a circle, like those in the examples provided, can be used at the end of a text: the circle is made with a compass, while the curved strokes are drawn by hand, alternated inside and outside the circle.

3. Banners and cartouches of various sizes, simple and elaborate, are always an excellent way to highlight short sentences, or even a single word.

2

3

61

If you want to create a more freeform frame surrounding a longer selection of writing, draw a rectangle in pencil that is large enough to contain the text, then photocopy it. Try out several designs, again in pencil, on the photocopies, drawing flourishes and curls and arranging them on both sides of the rectangular border for some balance. Make sure that the corners are well defined by your decorations.

Once you have created the perfect frame, transfer the measurements of the rectangle and the chosen frame to your final sheet of paper using pencil, and go over the lines with a fine-point marker. Add some embellishment, like leaves, flowers, or simple dots, and, finally, erase your pencil markings.

Now try designing a frame around rectangles with the same measurements as in the previous exercise, but this time using a broad-tip marker. The frames will be more simplified, with a completely different visual impact.

As in prior exercises, everything depends on the result you would like to achieve, on the type of lettering you will use for the text, and on the content of the writing itself.

Do some experiments, being careful to hold the marker at the same angle throughout.

Embellished Letters

Letters can be decorated in many ways. Even if these decorations look like in-the-moment improvisations in the final composition, they often must be practiced several times in order to create a pleasing effect that is, most importantly, appropriate for the letter.

Often, there is an actual risk of overdecorating, weighing down the overall effect in an outrageous riot of curlicues and flourishes.

This lowercase alphabet, replicating the shapes of chancery, adds some traditional flourishes and extensions, which are very simple and elegant.

Draw the guidelines for your chancery letters and write the entire alphabet with a fine-point pen, taking care that the final result is fluid, with no uncertainty in your stroke.

Now, to take a look at chancery uppercase, copy the illustration shown, writing the entire alphabet. Look closely at the letters for some significant variations, like the C that has been lengthened below the baseline, or the oblique strokes of the M and N, which are heavily emphasized.

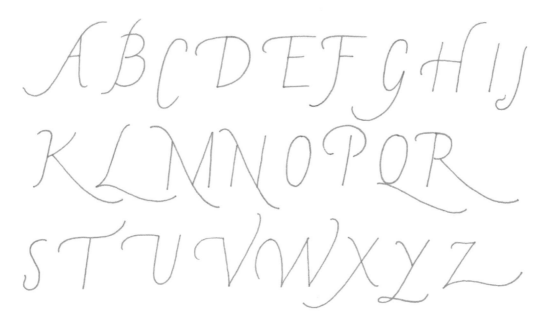

The following sentence is taken from a calligraphy manual from the 17th century and has been written several times using different pens: on this page it was written with a fine-point pen. It is useful, when writing letters and sentences with flourishes, to increase the line spacing a little to prevent ascenders and descenders from crossing.

1. The same sentence is written with a broad-edge nib held at a 45-degree angle.
2. In this case, the sentence is written with a fine-point pen, with thicker strokes built up using the same pen.

① *Arte de escrivir inventada con el fabor de Dios.*

② *Arte de escrivir inventada con el fabor de Dios.*

Here a broad-tip marker was used, held at a 45-degree angle. Note the differences in the text when it is written with different implements.

Arte de escrivir inventada con el fabor de Dios.

More Lettering Styles

So far, we have examined and learned about scripts and typefaces from the historical tradition of calligraphy, a critical exercise to establish certain fundamental principles that one must always bear in mind when it comes to lettering.

For example:

1. Draw guidelines with care.
2. Respect the structural relationships between letters of various styles.
3. Pay attention to the proportions that determine the height, width, and slope of a script or typeface.
4. Keep the angle of your nib steady.

When using instruments with a broad tip or brush and the writing angle has been decided, it must not be changed: the wrong angle can create strokes that are too thin or too broad, resulting in an unpleasant mess lacking harmony.

This having been clarified, we can begin to consider other shapes. Some new alphabet styles are therefore illustrated in this section, while others are clearly inspired by the classics. These are simple to execute, with differing characteristics and aims: some are smooth, others angular, some letters require a single stroke of the pen, and others a more laborious design.

These are just some of the thousands of ideas that lettering can offer, developing a creative pursuit that, for those who wish to deepen their experience, will always reveal itself to be rich and surprising.

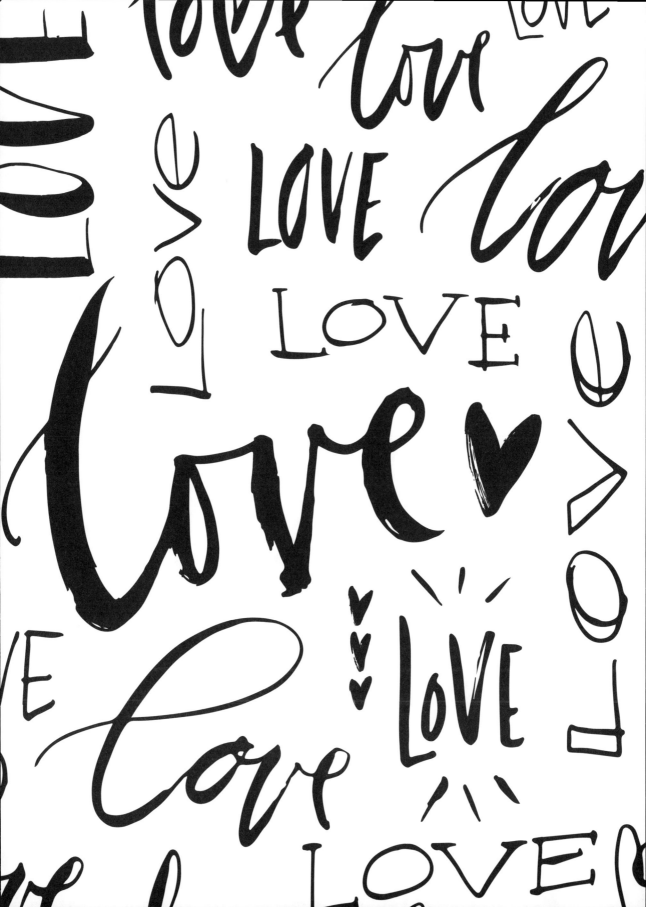

Alphabet 1

This lowercase alphabet is inspired by chancery, but the characters are perpendicular to the guidelines. The chief characteristic of these letters is the inverted teardrop shape used for ascenders and descenders, which can also be found in x-height letters. The shape of the letters is then executed in thin strokes, made with a fine-point marker. Thicker areas can be built up and filled with solid color or small polka dot patterns, or they can be left blank.

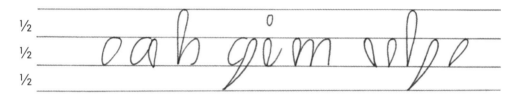

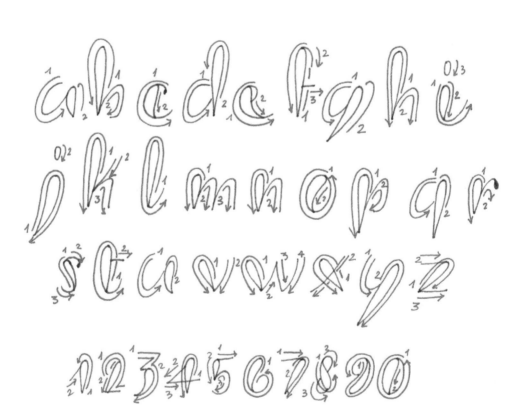

Try creating ligatures between the letters. In this kind of script, as in others, not all letters need to be joined, lending a greater sense of spontaneity to the overall composition.

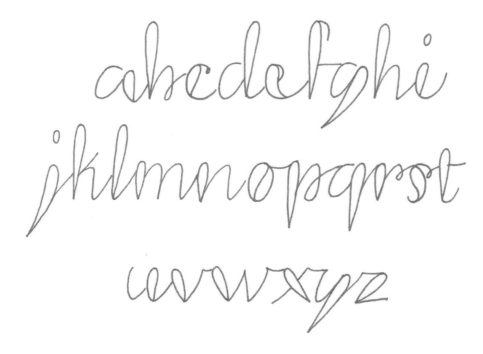

AN EXAMPLE

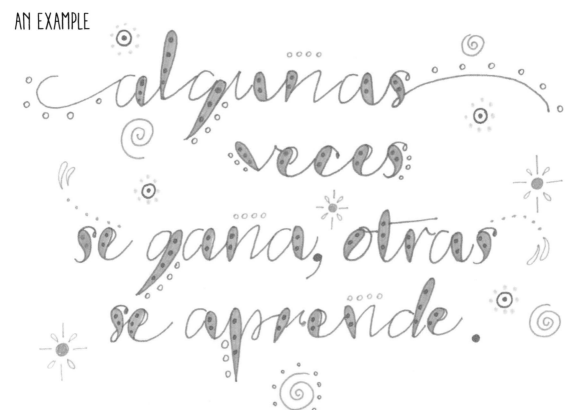

algunas veces se gana, otras se aprende.

Alphabet 2

This script in some respects is reminiscent of roundhand, defined by substantial eyelets in the ascenders and descenders. The lettering is straight, though it may appear to slope slightly to the left when parallels between the arcs and ascenders are respected. The script is written here with a medium-point marker.

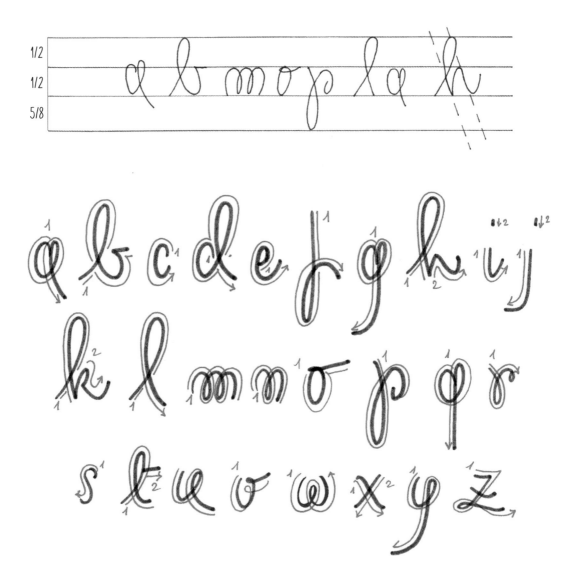

Write the lowercase letters and join them using irregular ligatures, trying to maintain the shape of the characters.

a bcdefghijkl
mno p qrstu
vwxyz

AN EXAMPLE

Fall sieben
Mal hin, steh
acht Mal
wieder auf.

Alphabet 3

These characters are based on the essential outline of chancery capitals but are, in contrast to chancery, perpendicular to the guidelines.

Make a module to measure the thick strokes (¼ in. or 0.5 cm, in this example) of the A and M, then draw the rest of the letters accordingly. Some still contain thin strokes.

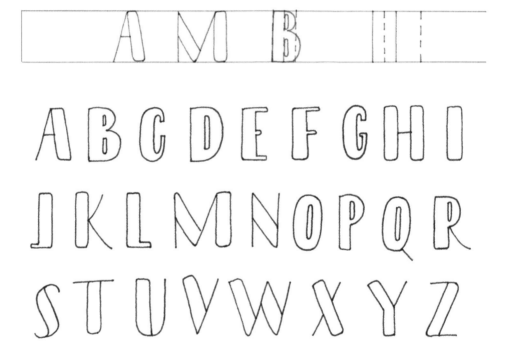

AN EXAMPLE

Broad fields of the letters can be filled in with ink or left open, or you can create an alphabet where letters are decorated with alternating full and empty areas, as in this example.

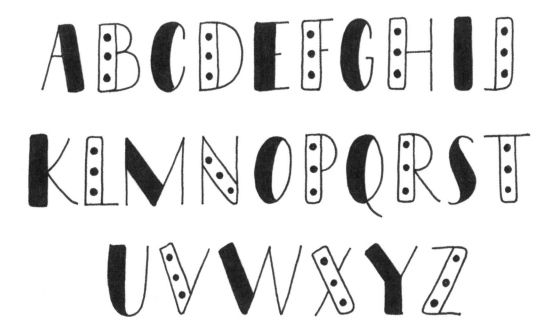

AN EXAMPLE

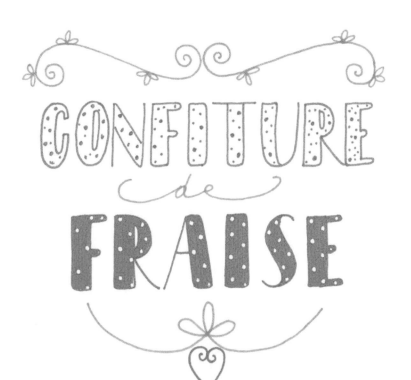

Alphabet 4

These elegant capitals have a very slight width, made with a fine-point pen or marker. Sloped slightly to the right, they can be given very subtle serifs by making a triangle, or you can end strokes with a thin stroke of the pen.

Further thickness can be added to strokes if you feel the need to enhance them with some decoration.

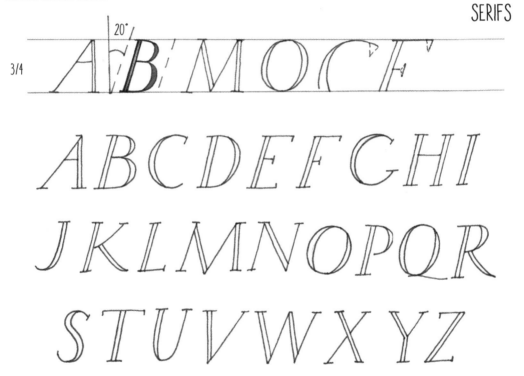

SERIFS

3/4

20°

A B M O C F

A B C D E F G H I

J K L M N O P Q R

S T U V W X Y Z

AN EXAMPLE

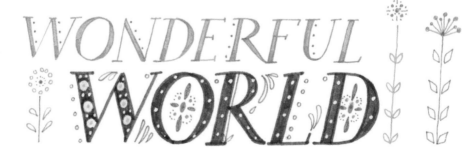

WONDERFUL WORLD

The curved letters C, G, O, and Q are written here without adding any further breadth.
They are decorated with leaflets, while a serif has been added to other letters.

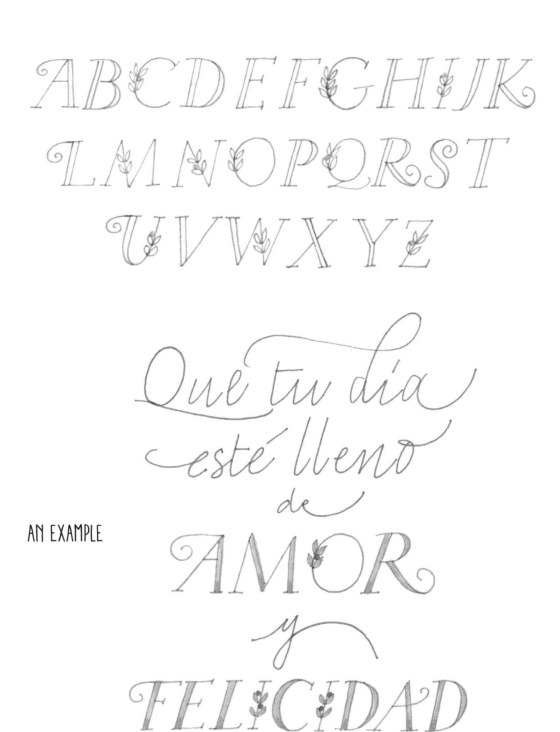

AN EXAMPLE

Alphabet 5

Once again, chancery provides a starting point for a new shape. In this very dynamic minuscule alphabet, written in fine-point pen, ascenders and descenders are written out in sweeping curves using a medium-point marker: take care that the letters are as similar to each other as possible.

To add further liveliness to the ensemble, you can write a few of these letters using only a medium-point marker. In the figure below, it is the "d" and the "s."

By now, you should have some experience recognizing the ductus of different letters. Practice figuring them out in the alphabets illustrated below.

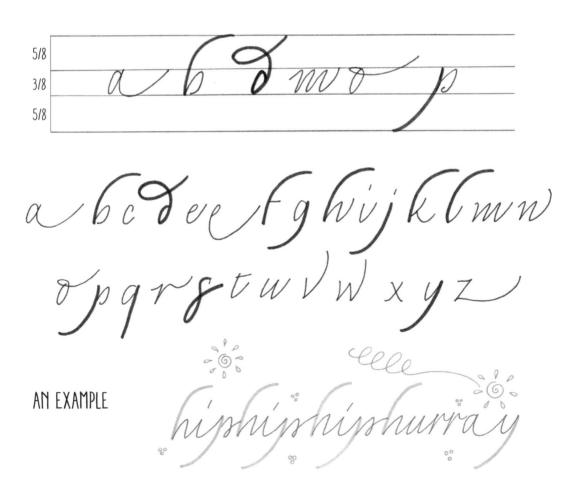

AN EXAMPLE

Create ligatures between these letters, lengthening some of the strokes to create an irregular rhythm.

a bcde fghijk lm
nopqr stuvwxyz

je mettrais

je mettrais

le bruit

le bruit de la mer

de la mer

dans mon

dans mon

AN EXAMPLE *oreiller.*

oreiller.

Alda Merini

79

Alphabet 6

This majuscule alphabet has a deco flavor, with triangular shapes that build up the thickness of its letters. Here, letters are measured against a pre-defined module, which is reduced slightly in select letters (e.g., M and N) to maintain a homogenous visual effect.

3/4 A B M O I O

A B C D E F G H I
J K L M N O P Q R
S T U V W X Y Z

AN EXAMPLE

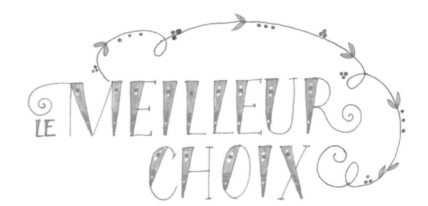

LE MEILLEUR CHOIX

The broadest parts of these letters are decorated very minutely, suited to their style, with strokes converging at the lower vertex of each triangle. If you wish to reduce the rigidity of the whole layout, you might add small leaf motifs or dots, in many colors or the same one used in the rest of the lettering.

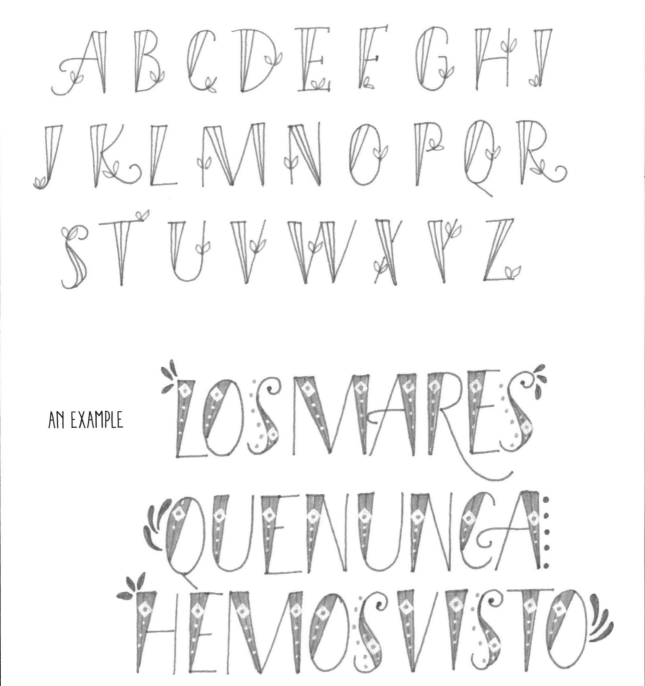

AN EXAMPLE

LOS MARES
QUE NUNCA
HEMOS VISTO

Alphabet 7

Here is a classic style of lettering for cartoons and birthdays, with cheerful, rounded letters to be colored in bright, flashy shades.

 Because the width of these letters is balanced, once again, we must begin by outlining their essential shapes (1). Write out the capital letters in their simplest form and, using a ruler, determine their thickness as in the examples. Make some adjustments to the width of select strokes, where the letter would otherwise look too heavy (e.g., H, R, W, Z).

 The counters in B, D, O, and Q can be made very small, to make them look "chubbier."

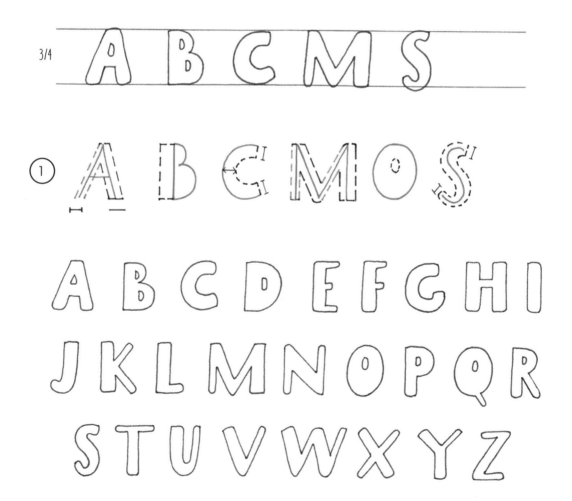

These are just a few examples of how these letters can be used. The ways are practically infinite. They can all match or be different from each other, and while that might be very tempting, it is advisable to exercise some moderation.

With this style, you can draw various shadow effects, or experiment with different thicknesses in the strokes and variation in the shape of the letters (e.g., the M).

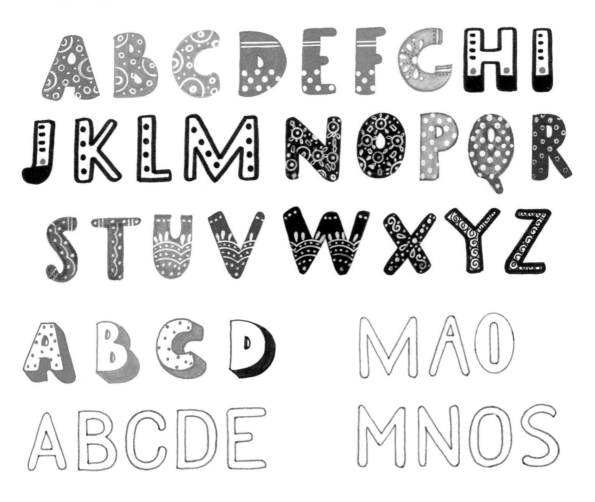

AN EXAMPLE

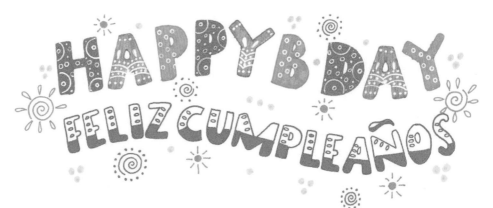

Alphabet 8

This alphabet is not exactly a single script or typeface, though with the appropriate modifications, it could become one. On this page, letters have simply been juxtaposed without using any particular criteria, drawing in part on historical models and partly using lettering styles you have already encountered in this manual.

Writing a passage in this eclectic style could be very challenging, but if the text is short, it can be interesting to mix completely different styles to achieve a unique result. This alphabet is, in other words, an invitation to search among the infinite possibilities that different typefaces and scripts offer, to study shapes and decorations as much as you can, and to find a way that it can all work. It is less simple than it sounds but is also a lot of fun.

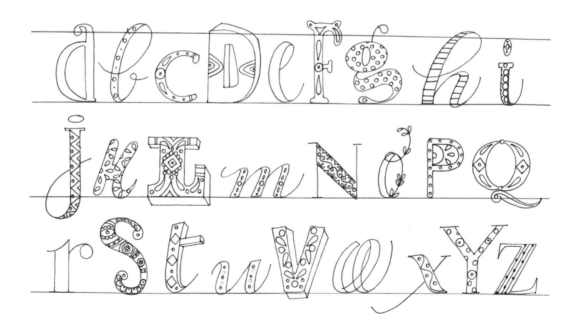

After writing out all these letters in pencil and drawing the decorations, continue to decorate with color, using pens. Give your imagination free rein in this exercise. This does not mean that you should throw out shapes and colors at random: evaluate them carefully at every step.

You will need to therefore make several attempts with the letters, the decorations, and your color selections.

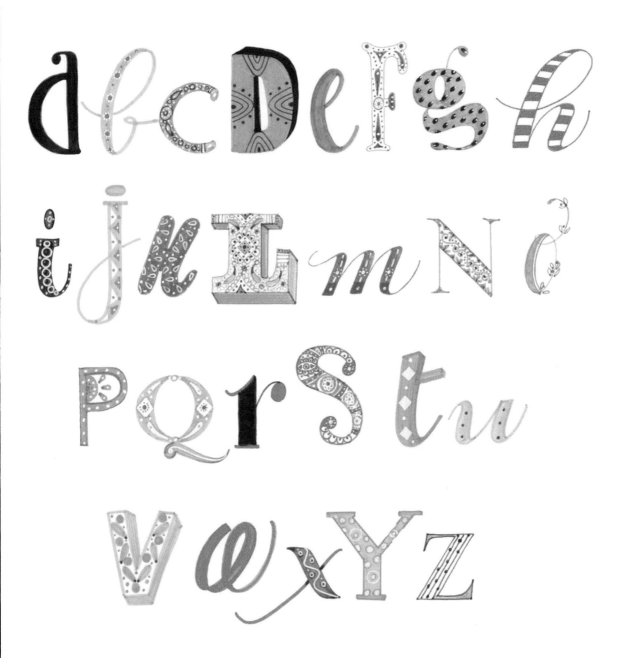

Seven Easy Lettering Styles

Now, following the opulence of the previous pages, here are a few lowercase and uppercase alphabet styles. These are simple and fairly commonplace but truly invaluable.

With its flexibility, this lowercase alphabet is easy to use for hand-lettered items. Very often, a single line of text written in this style turns a composition that would otherwise feel flat or incomplete into something much more interesting.

After you have written all the lowercase letters, add some small serifs, or write the alphabet mixing thin and thick strokes, using a medium-point marker for the latter.

3/8
3/8 a b g m n o o
3/8

STANDARD ALPHABET

a b c d e f g h i j k l m
n o p q r s t u v w x y z

WITH SERIFS ADDED

a b c d e f g h i j k l m
n o p q r s t u v w x y z

WITH BROAD STROKES

a b c d e f g h i j k l m
n o p q r s t u v w x y z

This uppercase alphabet also lends itself easily to small but very useful variations.

1. Make some of your strokes with a chisel-tip marker.
2. Do the same thing while enlarging the size of the letters slightly.
3. Write out the alphabet using a fine-tip pen, then use that same pen to create the broad strokes, completed with small serifs.

At the end, have a look at the distinct results you have obtained making these different alphabets.

3/8 | A B C M N O

STANDARD ALPHABET

A B C D E F G H I J K L M
N O P Q R S T U V W X Y Z

① A B C D E F G H I J K L M
N O P Q R S T U V W X Y Z

② A B C D E F G H I J K L M
N O P Q R S T U V W X Y Z

③ A B C D E F G H I J K L M
N O P Q R S T U V W X Y Z

The following is a very useful exercise: write out the same sentence for three different line lengths, aiming to keep the spacing between the letters balanced. There is no additional spacing between words in this exercise, and line spacing is kept constant.

1. 2-in. (5 cm) line length: the letters are very close together, and the text is not easy to read.
2. 2 ½-in. (6.5 cm) length: the layout of the text becomes easier, and legibility improves.
3. 3 ⅛-in. (8 cm) length: in this case, the distance between the letters allows one to introduce some graphic variation to better balance the spaces. Here the S and O become something like a comic illustration to underline the message of the text.
4. A greeting with a freer composition to depict a flowerbed.

①
WEILDUEINE
BESONDERE
PERSONBIST

②
WEILDUEINE
BESONDERE
PERSONBIST

WEIL·DU·EINE

③ BE»↦»ONDERE

PER»↦»ON·BIST

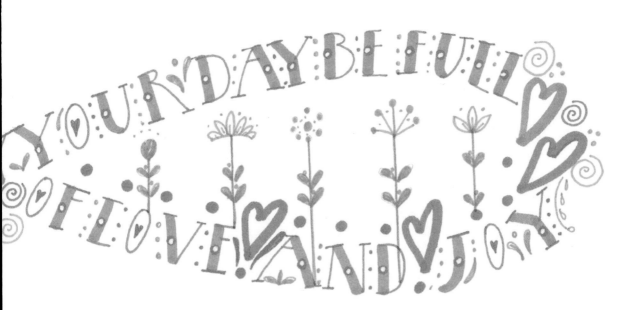

④

Projects

At this point, in order to add meaning to your practice, you are ready to tackle the execution of projects where letters will serve as your main protagonists.

The realm of possibilities is vast and highly entertaining. As you will discover in this section, any surface, or just about any surface, can be embellished with your designs.

From classic Christmas cards to T-shirts, to glass objects, everything can be made into something original, and very personal, using your unique letters.

The projects presented in this section are just a beginning, offering ideas that, while simple, are highly satisfying once they have been carefully executed.

WHAT YOU NEED

First, check that you have all the tools you will need to complete a project: pens, pencils, squares, rulers, compasses, etc. Decide on what paper or material to use for your final piece after you have made several drafts on sketch paper.

PREPARE A DRAFT

Once a style of lettering has been chosen, it is very important to prepare a draft to be clear about the composition as a whole, and to do so in detail.

In this section, you will find various designs that you can use. Some are simple, while others are more complex. You can use them just as they are illustrated or make changes and variations for the project you wish to complete.

Once you have chosen a selection of text:

1. Perform several tests by writing the text out, first using a pencil and then with the pen that you think is most suited for your first attempts.

2. Determine what kind of orientation best suits the text and characters: vertical, horizontal, or oblique.

3. Decide whether you wish to highlight a word or phrase using a different letter height, a new color, or another font.

4. Write all the text on your draft paper by measuring the sentences or words you are interested in highlighting, then writing the measure on the side in pencil.

5. Using a ruler, draw a layout scheme in pencil with the dimensions of the sentences or words, the line spacing, and their distance from the edges of the sheet. This distance will have a more pleasant effect if it is kept wider.

6. Photocopy and cut out your sentences and use them to compose one or more drafts, fixing them with removable tape on a piece of paper. This way, you will be able to figure out which changes will improve your composition more easily and more quickly.

7. Choose a paper for the final stage of your project, making some tests on the kind you intend to use. If you plan to write on another surface, make your test on a separate sample or in an inconspicuous area.

8. When making your final version, faithfully transfer your measurements and write using your chosen pen, lightly tracing the guidelines with a soft pencil that will be easy to remove.

Notebooks

Decorating the cover of a notebook, an agenda book, or a notebook perhaps made by hand is quick and easy: you can find many models and formats at a stationery store to enrich with your touch.

Notebooks with a Colored Spine

NOTEBOOK "100"

1. The notebook pictured here has about 5 ⅜ x 8 ¼ inches (13.5 x 21 cm) of space available to decorate. Draw the layout on a sheet of sketch paper. Find yourself some fine- and medium-point white, yellow, and blue gel pens and black markers. Draw the vertical midline, AB, and the other straight lines, forming guidelines CD, EF, GF, HI, LM, and NO.

2. Practice several times in pencil using different letter styles in your layout, marking out the broad strokes of letters.

3. Make sure that the letters between the diagonal guidelines have the same slope, and practice your decorative flourishes.

4. Once the dimensions have been established, transfer the measurements and text onto the notebook. Retrace the design using markers, adding small decorations in places.

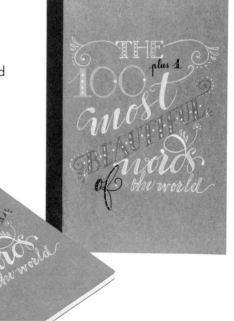

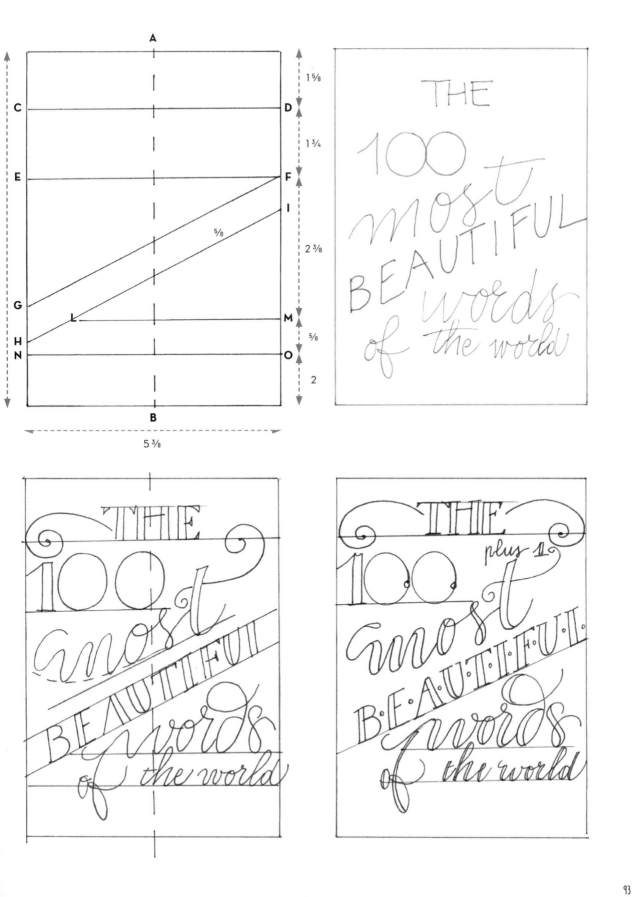

93

"It's Easy" and "COSE" Notebooks

These two notebooks have a very simple design, with small variations that demonstrate how the selection of fonts, dimensions, and colors can produce a unique effect with little effort.

Here, the available space measures 4 ⅛ x 6 ¾ inches (10.5 x 17 cm). In pencil, draw the layout, the vertical midline, AB, and the guidelines CD and EF on a sheet of sketch paper, which will form the central band of text on each notebook.

6 ¾

4 ⅛

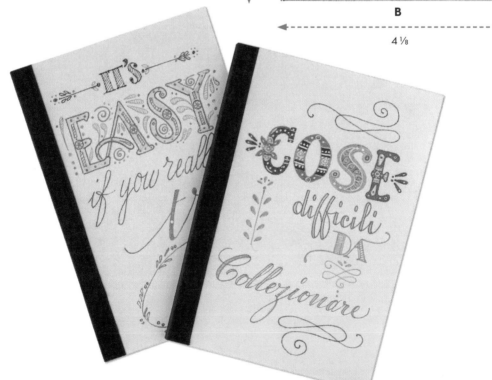

"IT'S EASY" NOTEBOOK

1. The notebook shown has an available size of 4 ⅛ x 6 ¾ inches (10.5 x 17 cm). Draw on a sheet of sketch paper, in addition to the lines already shown, guidelines GH, IJ, and KL. Get some normal fine- and medium-point markers and gel pens of different colors, keeping to light and pastel tones.

2. Pencil in the outlines of the larger letters and the others, marking out broad strokes; take care to be precise when making the loop of the final letter "y," so it elegantly and harmoniously fills the space.

3. Now that the measurements and text have been transferred to your notebook, fill in the larger characters with soft colors and adorn with them with small decorative elements. You can fill spaces between the letters with small leaves that will not weigh down the overall design.

4. Continue with the other letters and embellish the loop of the "y" with small leaves, just outlining it with a gel pen.

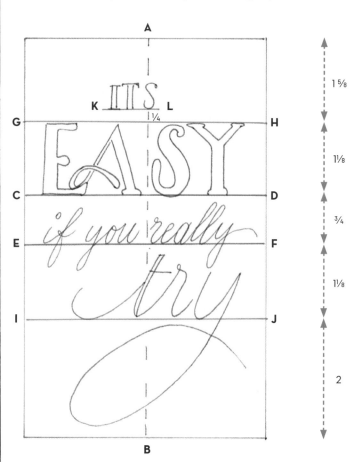

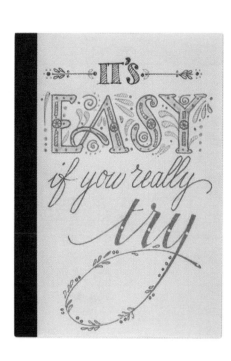

"COSE" NOTEBOOK

1. The notebook shown has a size of 4 ⅛ x 6 ¾ inches (10.5 x 17 cm). On a sheet of sketch paper, draw guidelines GH, IJ, LK, and others. Find some normal fine- and medium-point markers and gel pens of different colors, this time selecting very bright, vivid colors.

2. Draw the outlines of the largest letters, and the others, marking out their broader strokes. If you see places where you would like to add flourishes and decorations, draw these in very lightly.

3. Then, transfer the measurements and text to your notebook; fill the larger letters with bright, very solid colors, adding decorations to them in the same way.

4. Trace over your flourishes and decorations.

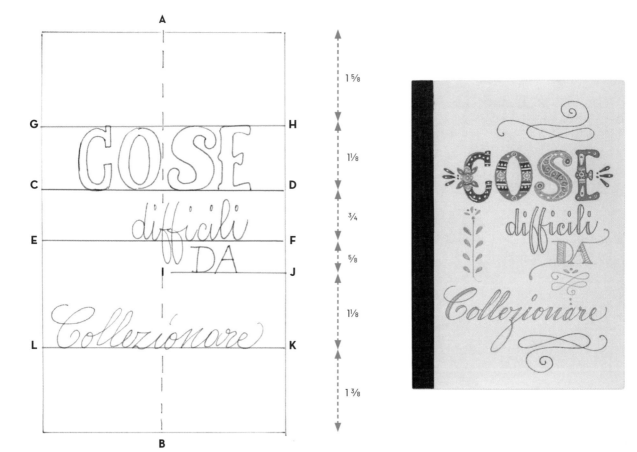

"GLÜCK" NOTEBOOK

1. Here we are using the dimensions 4 ⅛ x 6 ¾ inches (10.5 x 17 cm) once more. Draw the vertical median AB and lines CD and EF onto a sheet of sketch paper, then divide the space within this section as illustrated in the template.
 From point B of the midline, mark out the measurements of RS and TU, as shown. Then assemble some fine-tip red, green, and pink markers.

2. Write the text using a very slim lettering on the left-hand side, then draw the thicker strokes and outline of the letters "VIEL GLÜCK" on the right.

3. Transfer the measurements and text onto the notebook and trace the letters. Fill the wider areas of the text on the left in red and the letters "VIEL GLÜCK" with pink dots. Mark out the umlaut of the letter Ü and incorporate it into the text above, making bold use of colored ink. Use your green marker to create a border of flourishes at the bottom and small flourishes at the top, then fill in empty spaces within the text.

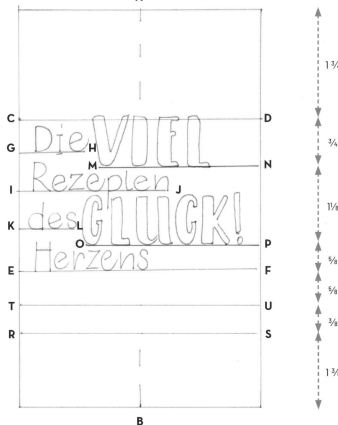

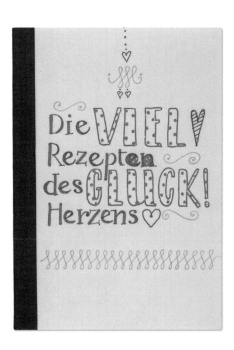

Handmade Notebooks

Notebooks that are made by hand, with eco-friendly paper and original bindings, have a special feel and are very suited to decoration with unique lettering. The dimensions of the notebooks pictured are 6 ¼ x 8 ¾ inches (16 x 22 cm).

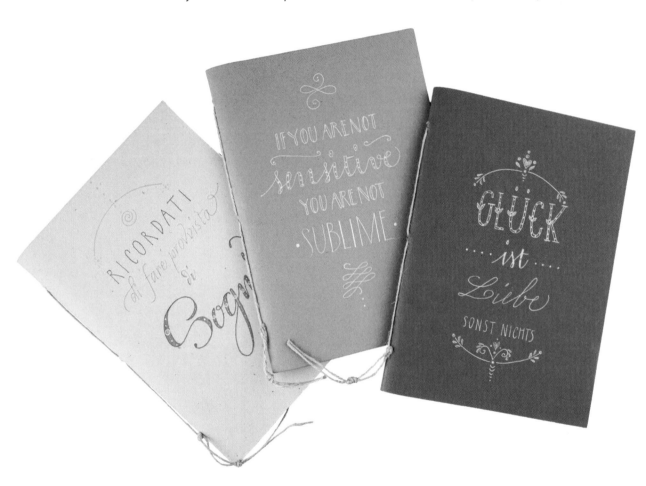

"SOGNI" NOTEBOOK

1. Gather some fine-tip light and dark blue gel pens and a fine-tip gold marker pen. Plot the measurements of the layout on a sheet of sketch paper as illustrated in the template, and draw the midline, AB, and guidelines CD, EF, and GH. Then draw line IJ.

2. Mark an X on vertical midline AB.

3. Centering a compass on this X, draw an arc beginning and ending at line IJ.

4. Write the text and outlines of the word sogni ("dreams"), which should stand out significantly from the rest of the text.

5. Lay out the measurements and text on your notebook in pencil; fill the broad areas with a dark blue gel pen and small gold circles.

6. Using the fine-tip gold marker pen, trace the arc and some small decorations.

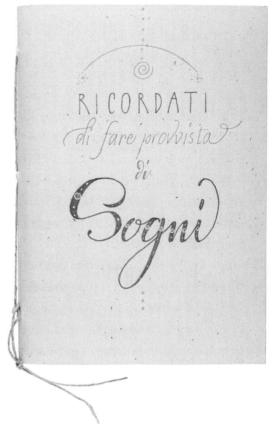

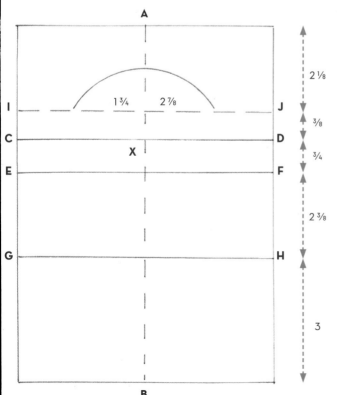

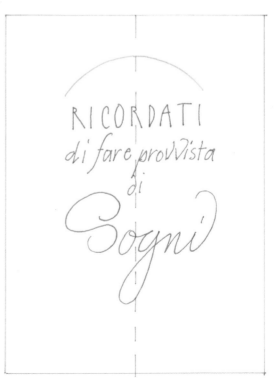

"SUBLIME" NOTEBOOK

1. Lay out the measurements on a sheet of sketch paper as the template illustrates. Draw your midline, AB, and the guidelines CD, EF, GH, and IJ. Then find a fine-tip white marker pen.

2. Write out the text in its various lettering styles, adding the broad areas of the letters. Transfer the measurements and text onto the notebook.

3. Trace the text with the white marker. Fill the thickened lines of the word "sensitive" with small white polka dots and complete it with very light white flourishes above, below, and between the lines of text.

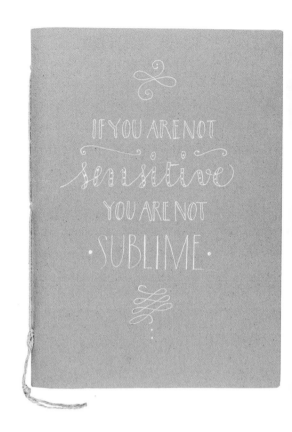

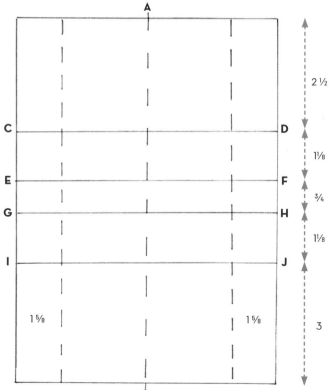

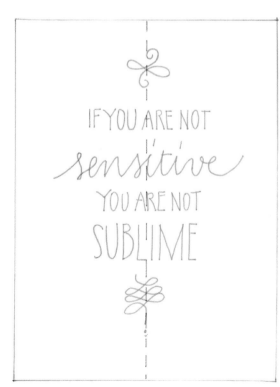

"LIEBE" NOTEBOOK

1. Gather fine-tip light blue gel, silver gel, and white marker pens. Plot the measurements of the layout on a sheet of sketch paper as shown in the template. On the vertical midline, mark points X and Y. Placing the needle of an open compass on point X, draw a small upper arc. Then, centering the open compass on Y, mark a small lower arc.

2. Write the text in pencil and the outline of the word "GLÜCK," then transfer your measurements and text on the notebook. With the silver marker, write the word "GLÜCK" and fill the wider strokes of the letters with silver dots. Write the rest of the text with the white marker. Again using the white marker, trace the upper and lower arcs; decorate both the arcs and the word "GLÜCK" with small blue leaves, hearts, and white dots.

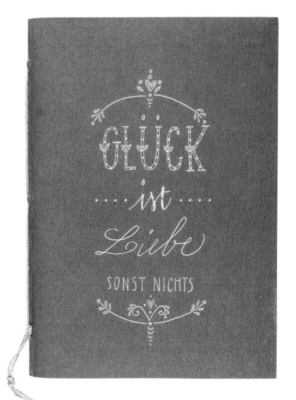

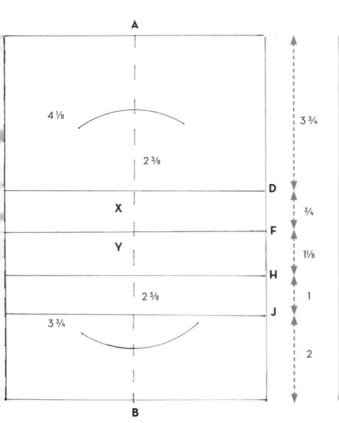

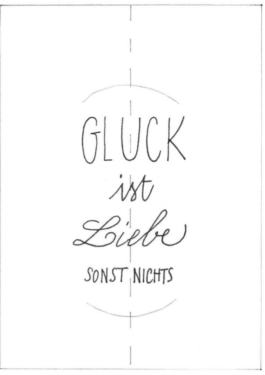

Planners and Journals

It is easy to find planners and journals in many colors and sizes. They often come with laminated covers, in which case permanent markers are very useful.

"LUCK" NOTEBOOK

1. Draw the layout on a sheet of sketch paper; the dimensions in this case are 5 1/8 x 8 1/4 inches (13 x 21 cm). Mark the vertical midline and guidelines CD and EF. Find yourself a fine-point white marker and a medium-point white marker.

2. Write the text so that the word "good" is more prominent than the others.

3. Write your letters so they are not overly regular; transfer measurements and text onto the diary and trace the text with the fine white marker.

4. Fill in the broad strokes of your letters using the medium white marker; you can then add small decorative elements in white and gold.

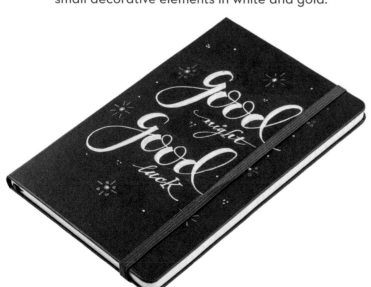

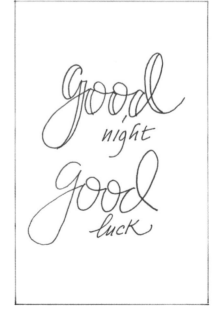

"WRITE" AGENDA

1. Draw the template on a sheet of sketch paper; its dimensions are 5 ⅛ x 8 ¼ inches (13 x 21 cm). Draw the vertical midline, AB, and guidelines CD, EF, GH, IJ, and KL.

2. ⅝ inch (1.5 cm) left of the vertical median line, AB, draw line MN parallel to it, starting at the top of the layout and reaching line IJ: this will be the alignment line for the first block of text. Find a fine-tip black marker and a medium-point white or pink marker.

3. Write out the text, with broad strokes, and transfer the measurements and writing onto the diary; start from the first block, using line MN for alignment, giving it a slightly irregular feel.

4. Now write the rest of the text, taking care that the word "WRITE" spreads evenly across the space.

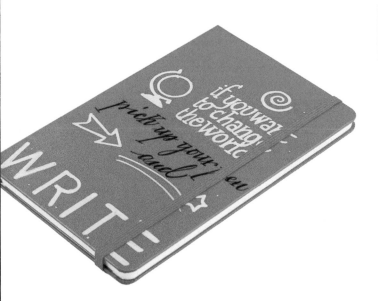

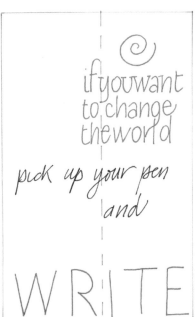

"TO-DO" NOTEBOOK

1. The dimensions of this horizontal notebook are 3 ½ x 5 ⅛ inches (9 x 13 cm). Draw the layout onto a sheet of sketch paper as shown and mark the vertical midline, AB. Then gather a medium turquoise marker, a fine-tip white marker, and a copper-colored marker.

2. Draw three curved lines that occupy the space in the design rather freely, keeping the height of the letters in mind. Try out a few different options until you reach a satisfying result.

3. Then transfer the measurements and writing onto the notebook and retrace the words with markers, filling in the broad strokes. Decorate with short white strokes and copper polka dots.

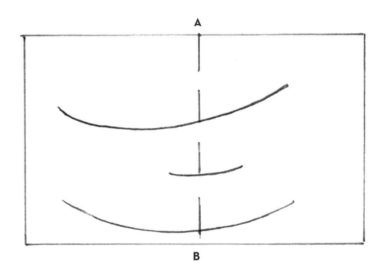

"TRÈS" PLANNER

1. This planner has a vertical format, with the same measurements as the previous notebook, 3 ½ x 5 ⅛ inches (9 x 13 cm). Gather a pink medium-point and a black fine-tip marker, then draw the layout in pencil as shown.
2. Mark line XY, ⅝ inch (1.5 cm) from the right edge, which will be used to align the text. Then mark out guidelines AB, CD, and EF.
3. Write the text in three different characters, making the word "TRÈS" most prominent. Then transfer it to the cover of the planner.
4. Draw out the word "TRÈS" using the pink marker and the rest of the text using the thin black marker.

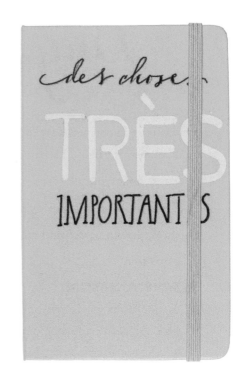

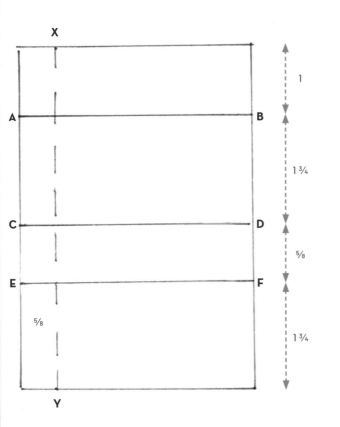

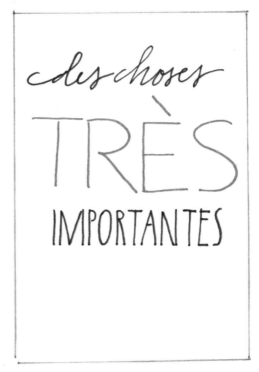

Bags and Totes

Bags made of cloth and paper can be used either to accompany a special gift or to store your clothing, make-up tools, books, and so on.

Both versatile and useful, bags can also be turned into something original with colored or monochrome lettering. Then, once they have fulfilled their original task of carrying items, bags can be cut and transformed into a unique picture to be framed and hung.

BEFORE YOU BEGIN

1. If the bag is made out of decorative paper and you already have some experience, you can draw a layout and lettering directly onto it, since any (likely rare) erasures should be easily tolerated. Otherwise, you can draw them onto sketch paper and then draw them onto the bag.
2. If the bag is made of fabric, wash it to remove any traces of starch that would prevent a good absorption of the ink and then, once dry, iron it well. Write your text onto a sheet of paper, which you will place inside the bag and trace with the pencil onto the fabric. Then remove the sheet of paper and insert a piece of cardboard in its place so your ink does not bleed through to the back of the bag. Once finished, fix the colors with a hot iron, protecting the bag with a piece of cotton cloth. Once ironed, the colors will be perfectly set and become resistant to washing, even in the washing machine.

"MOMENT" BAG

1. The measurements of this bag are 9 x 11 ½ inches (23 x 29 cm). Draw the layout in pencil as shown, positioning it relatively high if you are writing onto the bag. Gather fine- and medium-point black and white markers, as well as a red marker.

2. Mark out the vertical median line, AB, and the guidelines CD, EF, GH, IJ, and KL. Then, from points X and Y, about 2 ⅜ inches (6 cm) from A, draw two straight lines parallel to the median until they touch IJ.

3. Write out the text, emphasizing the word "moment" and marking out the thicknesses of different strokes, then trace and fill them with the fine-point black marker.

4. Decorate broad strokes in the word "moment" with white dots and a few stars to create points of light.

5. Along the lines parallel to the median, draw two curly brackets with the black marker lined with dots of the same color.

6. Finally, if you like, finish with a small red heart positioned below the last line of text, surrounded by fine black strokes, which you will make around a circle that has been traced in pencil with a compass.

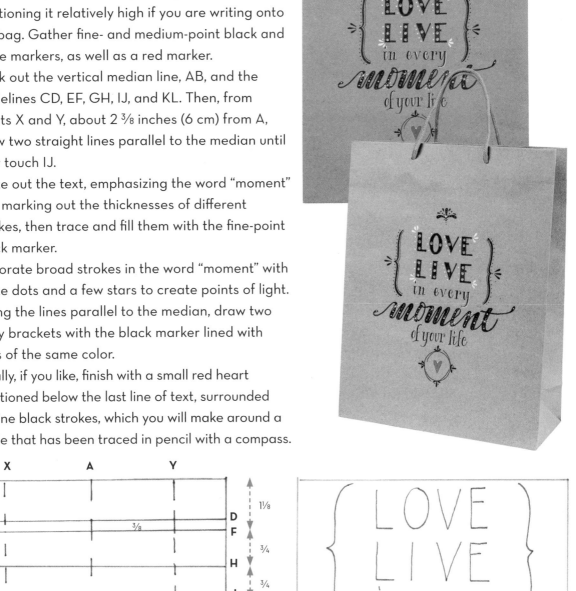

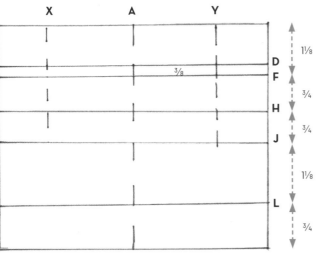

"SUNSHINE" BAG

1. A medium-sized bag: 12 ¼ x 16 ½ inches (31 x 42 cm). Draw the layout in pencil as shown, positioning it relatively high if you are writing onto the bag. Gather fine- and medium-point white markers.

2. Mark the vertical midline, AB, and guidelines KL, CD, EF, GH, and IJ.

3. On the median, draw point X 2 ½ inches (6.5 cm) from line KL. Centering the compass on point X with an opening of 5 ⅛ inches (13 cm), draw an arc tangent to IJ until you meet the vertical lines at the side edges of the layout. Again with the compass placed on X, draw a second arc ¾ inch (2 cm) from the first. Then, again from X, draw two arcs, the first with an opening of 4 ⅛ inches (10.5 cm), the second at ⅜ inch (0.8 cm) from the first.

4. Now mark point Y on the median, 1 ¾ inches (4.5 cm) from line IJ. Placing the compass on Y with an opening of 5 ⅞ inches (15 cm), draw an arc tangent to KL until you meet the vertical lines at the sides of the layout. Again with a compass on Y, draw a second arc 1 ⅛ inches (3 cm) from the first.

5. Write "Sun," "Shine," and "of my life" on the respective guidelines, marking out the different thicknesses of the strokes. When writing "Sun," leave some diamond-shaped areas of background color inside the letters for decoration. Experiment several times for the best result.

6. Then write out the phrases "YOU ARE THE," "THAT'S WHY I'LL ALWAYS," and "BE AROUND" in their repetitive arcs, as shown, marking the shape of the strokes. Make sure that the letters are always perpendicular to the guidelines. Note: The length of the sentence "of my life" determines the length of the sentence "that's why I'll always."

7. Once you have written everything in pencil on the bag, trace the letters with the fine-point white marker, including broad strokes and outlines. Fill in the letters of the word "SUN" with the medium-point white marker and decorate the diamonds with small white dots. Build up the remaining letters in the upper and lower arcs using a medium marker.

8. Use white decorations to embellish the composition above the arcs, between the letters, and at the beginning and end of the phrases. If you like, you can add a couple vertical decorative elements, like flowers or flourishes, to frame the composition.

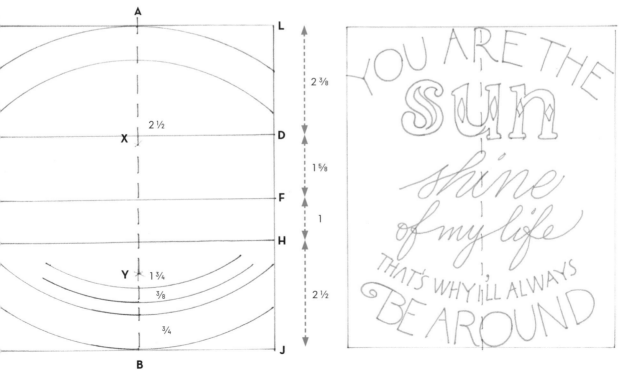

"PICCOLE COSE" TOTE

1. A small 9 x 11 ½ inch (23 x 29 cm) cloth bag to hold small items, like cotton balls. Wash the bag, let it dry, and iron it. Then collect some fine-tip fabric markers in green, dark pink, and orange.

2. On a sheet of sketch paper that is the size of the bag, draw the layout, with vertical median line AB and guidelines CD, EF, GH, IJ, KL, and MN, as shown. In the center of the layout, mark point X on the median; place the needle of the compass on point X and draw a circumference with an opening of 2 ⅜ inches (6 cm).

3. Write the text in pencil, mark out the thicknesses of different strokes, and draw a flourish on top of line CD. Then trace everything with a black fine-point marker. Insert the sheet inside the bag and trace it onto the fabric using a pencil.

 Once you have traced the text and flourish, take out the sheet of sketch paper and put a piece of cardboard in its place.

4. Trace the text with the fabric markers and fill in the strokes, then decorate the round frame with small colored leaves and berries. Let the ink dry, then remove the cardboard and iron the bag, protecting it with a piece of cotton cloth.

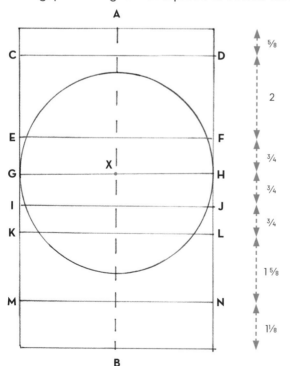

"MEILLEUR" BAG

1. The dimensions of this cotton bag are 14 ⅛ x 16 ⅛ inches (36 x 41 cm). Wash the bag, let it dry, then iron it. Get some fine- and medium-point fabric markers in purple, green, pink, and sepia.
2. On a sheet of sketch paper the size of the bag, draw the layout; vertical median line AB; and guidelines CD, EF, GH, IJ, KL, and MN as indicated. 1 inch (2.5 cm) from the left and right edges of the layout, draw two lines parallel to them, to use as a reference for the frame.
3. Write the text in pencil, mark out thin and broad letter strokes and the lines of the border, then trace everything with a black fine-point marker.
4. Insert the sheet of paper inside the bag and trace it onto the fabric with a pencil. Once the text and the frame have been traced, remove the sheet of sketch paper and put a piece of cardboard in its place. Trace the text with fabric markers, fill in the thicknesses of different strokes, and decorate the frame with small colored leaves and berries.
5. After the paint has dried, remove the cardboard and iron inside out, protecting the bag with a piece of cotton cloth.

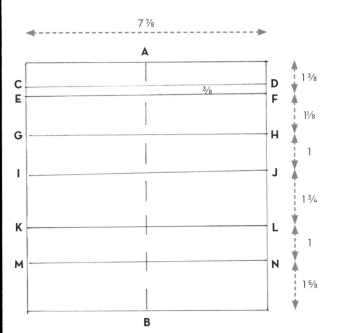

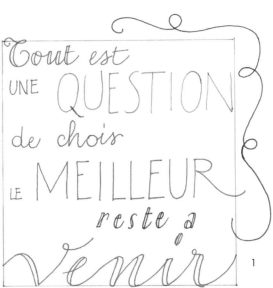

"LA MER" BAG

1. Find a tote bag made of jute canvas. The bag shown measures 15 x 16 ½ inches (38 x 42 cm). Wash the bag by hand in cold water. Do so with care, as handling it too much tends to cause fraying. Gather some broad-tip fabric markers or pots of fabric paint in different shades of blue, a large orange marker, a fine blue marker, and a white marker.

2. On a sheet of sketch paper the size of your bag, draw the layout with guidelines AB, CD, IJ, and KL as shown. The text will be aligned with line XK on the left, with lines EF and GH forming a wave pattern. Draw the starfish and spiral decorations as well.

3. Write the text in pencil, outlining and drawing the different thicknesses of the strokes and decorations, then go over the entire design with a thick black marker. You can then make the design again, with some variation, for the other side of the bag. Place the sheet inside the bag and trace everything onto the jute with a white tailor's pencil. If the weave of the canvas is too dense, you can use a light source like a window or, even better, a light table if you have one. Once the text and decorations have been traced, remove the sketch paper and insert a piece of cardboard in its place. Trace the writing with your fabric markers, filling the contours and the thicknesses of the letters, then add strokes of white to add some dimension to the letters. Go over your letters and decorations with paint several times, as jute is very absorbent.

4. When the paint is completely dry, remove the cardboard. Turn the bag inside-out and iron it, protecting it with a piece of cotton fabric.

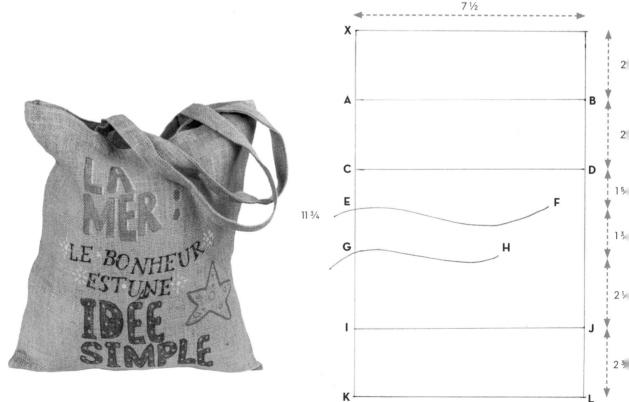

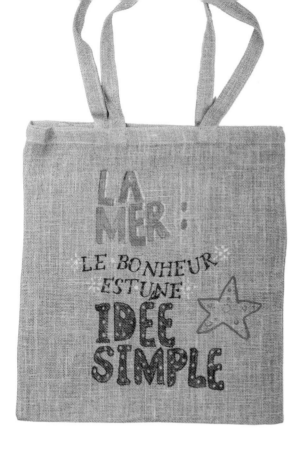

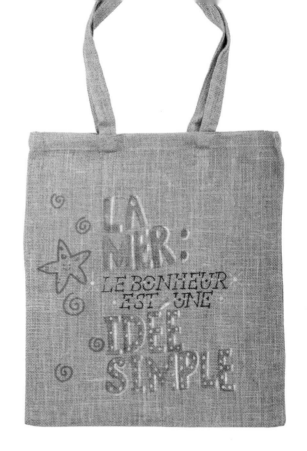

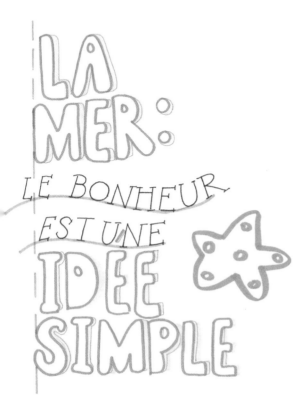

"HISTOIRES" BACKPACK

1. This handy backpack measures 14 ⅝ x 16 ⅛ inches (37 x 41 cm). First, wash the backpack, let it dry, then iron it. Gather some fine-tip fabric markers in white, gold, and different shades of blue.

2. On a sheet of sketch paper fitting the size of the backpack, draw the layout, center line AB, and guidelines CD, EF, GH, IJ, KL, and MN as shown.

3. Write the text using lettering of different styles and heights, emphasizing the words "*HISTOIRES*" and "*PROFONDS*" (these will be the only two words to occupy the entire width of the design). Then write the other words on the left and right sides of the midline, making sure there is a sense of balance. Fill the spaces above, below, and between the words with decorative elements, so that there are no empty spaces in the design. Finally, trace everything with a black marker.

4. Insert the sheet of paper inside the backpack and trace everything onto the fabric with a pencil. Once the text and decorations have been traced, remove the sheet of sketch paper and insert a piece of cardboard in its place. Trace the text using the fabric markers. Remove the cardboard, let it dry, and iron it while inside-out, protecting the backpack with a piece of cotton cloth.

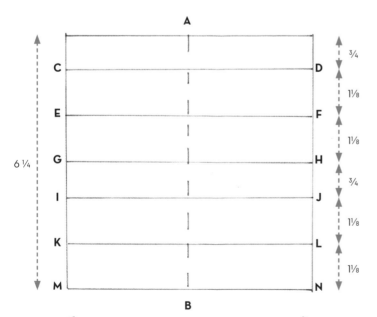

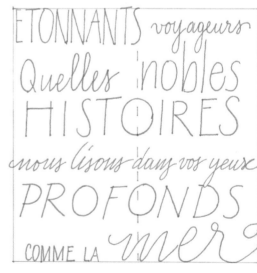

T-Shirts

Over the years, T-shirts with written sayings have become an everyday clothing staple. Whether sweet or sporty, they are versatile and fun. Finding the message that fully represents you is not always easy, so this section offers some examples and all the directions you will need to make a very personal T-shirt for yourself or as a cherished gift.

BEFORE YOU BEGIN

Fabric paints are readily available in fine art and craft supply stores. Once you have chosen the text, gather some fabric markers in your desired colors, in various sizes. If you prefer, fabric paints can also be used in liquid form, applied with a brush.

1. Always prepare a draft in pencil on a sheet of sketch paper. Determine the lettering style and shape of your text, then trace it with a black marker. Then place the sheet inside the T-shirt so you can trace it onto the fabric with a pencil.

2. Once you have finished writing, remove the template and place a rather thick piece of cardboard inside, so that the color does not bleed through to the back of the T-shirt. Then proceed to lettering with the fabric paint, using the colors you have chosen. All that is needed to fix your colors is to iron the T-shirt inside out once it is dry, placing a piece of fabric inside for protection.

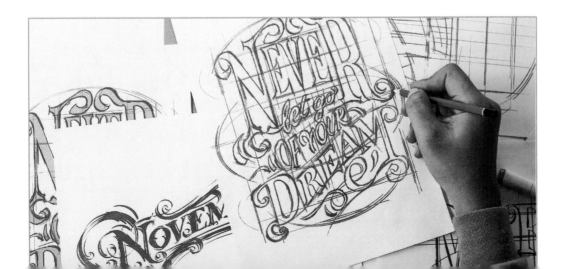

"GOETHE" T-SHIRT

1. Find yourself a white T-shirt, as well as medium- and fine-point markers in blue, green, black, and red.

2. In pencil, draw the layout that will contain the text onto a sheet of sketch paper. In angles X and Y of the template, draw two circles of equal diameter using a compass. Then, starting from X, draw a frame made of flourishes weaving harmoniously in and out of the template's outline. Inside the frame, draw vertical median line AB and guidelines CD, EF, GH, IJ, and KL with the measurements shown; IJ should have an up- and downward curve, as illustrated.

3. Write the text in pencil in your chosen styles, marking out different thicknesses in the letters, then trace them with a fine-point black marker. Add small leaves to the border flourishes, finish your flowers, and scatter some other decorative elements, like a bird or hearts, around the text. Place the sheet inside the T-shirt, then trace the text and all the decorations with a blue pencil. Once the tracing is finished, remove the sheet, insert some cardboard, and go over your design again, this time with fabric markers.

4. Let everything dry, then iron the T-shirt while inside out.

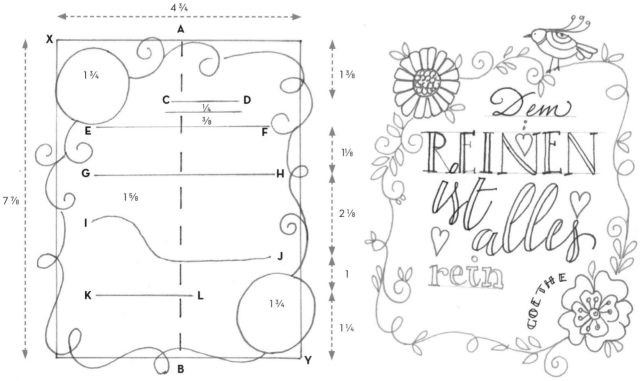

"LOVE" T-SHIRT

1. Find yourself a colored T-shirt in the desired size, black and white medium- and fine-point fabric markers, and a small jewel button or rhinestone.

2. Draw the layout, vertical midline AB, and guidelines CD, EF, GH, and IJ.

3. Write the text in pencil, marking outlining broad and fine strokes. Make sure that there is more space around the letter "I" in "Beautiful," making space to draw a heart matching the height of the letters. Trace all the text with a black medium-point marker. Place the sheet of paper inside the T-shirt and trace the lettering with a pencil. If the T-shirt is very dark, you will need a light source like a window or a light table, if you have one. Once you have finished tracing, remove the paper, place some cardboard inside, and trace it again, this time using your markers, and fill in the letters. Fill in the large heart containing the letter I with the color of your choice.

4. When all the lettering is dry, iron the T-shirt while inside out, as usual. To lend a touch of sparkle to this minimalist top, sew the jewel button or rhinestone directly on top of the heart, using thread matching the color of the T-shirt.

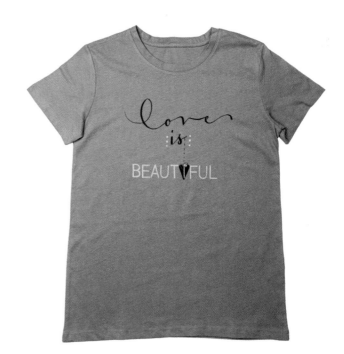

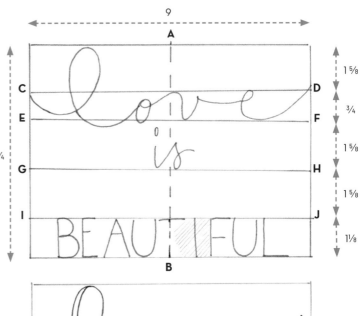

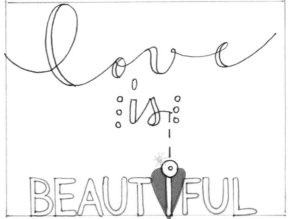

"SHOW" T-SHIRT

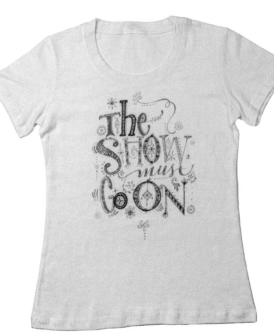

1. This T-shirt allows you to experiment with several different lettering styles. Find a T-shirt in a cream or natural tone, markers of varied colors and sizes, and a gold marker or fabric ink.

2. Prepare the layout in pencil on a sheet of paper, drawing vertical midline AB and guidelines CD, EF, and GH. Letters can be arranged freely within these lines so long as the result is balanced.

3. Write the text in pencil with your chosen characters, marking out different thicknesses, then trace with a fine-tip black marker. You can play with all kinds of letter styles and decorations inside the strokes, using circles, zigzags, small petals, or geometric patterns. Place the sheet of paper inside the T-shirt, then trace the text with a pencil. Once you are done tracing, remove the sheet, insert a piece of cardboard, and trace the design again using markers. Use all of the colors, and, if you like, write one of the words all in gold. Adorn the design with flourishes, petals, spirals, sparkles, and diamond shapes, all in gold ink.

4. When all the paint and ink is dry, fix them by ironing the T-shirt inside-out.

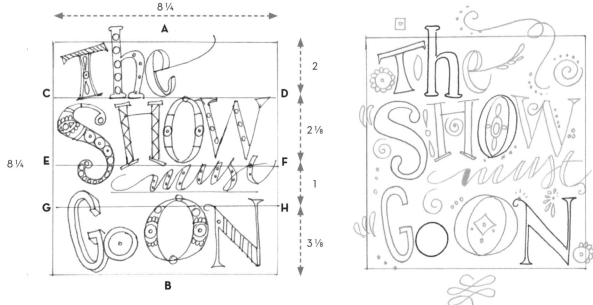

"ASCOLTA" T-SHIRT

An alternative way to make T-shirts with creative writings is to have them printed. The words in the example were taken from a poem by the brilliant Polish poet Wisława Szymborska, and translated into Italian. As in other examples, you can draw the layout using the template provided, using a very informal, expressive font to make an even more powerful impact on the lettering of the text.

1. Prepare your layout in pencil with guidelines AB, CD, and EF on a fairly thick sheet of paper. Experiment with different fonts, colors, and tools.
2. A drawing pen was used to make the final T-shirt shown; this allows for original, irregular strokes. You can use markers, brushes, or nibs for the result you want to achieve.
3. When you have made your final version, take it to a shop specialized in digital printing. There your text can be reproduced onto several pieces if you like, and the results can be truly remarkable.

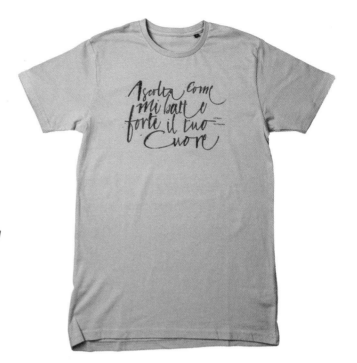

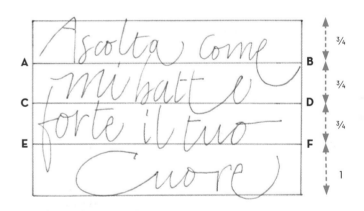

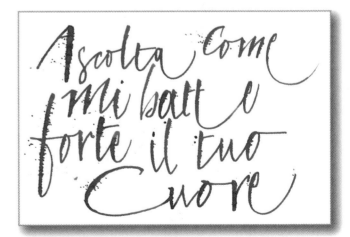

Boxes

Gift boxes made of stiff cardstock are available on the market in countless shapes, colors, and sizes. This section provides some templates and examples to use for decorating ready-made boxes and making boxes by hand, either to wrap a special gift or to serve as a gift themselves.

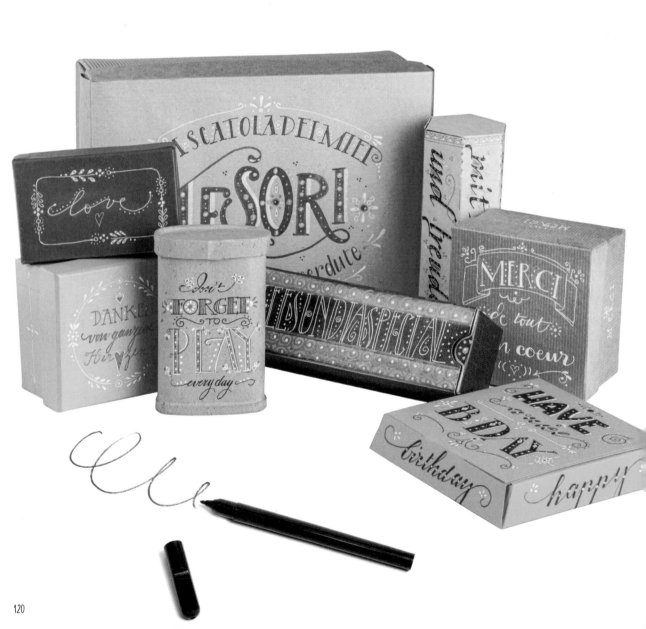

"HAPPY BIRTHDAY" BOX

1. On a relatively thick, colored piece of cardstock, draw the diagram with the measurements shown in the template and cut it out along the edges.

2. Draw guidelines AB, CD, EF, GH, and IJ on square ABCD and write out your letters.

3. Again in pencil, write the text on the sides of the box. Then trace the text with a fine-point black marker. Outline the broad areas of the letters with a fine-point white marker, then fill them. Decorate the inside of the letters with small diamond shapes and dots. Do the same with the writing on the sides of the box.

4. Once the writing has been completed, fold the sides of the box inward; to close it, insert the tab into the appropriate slot.

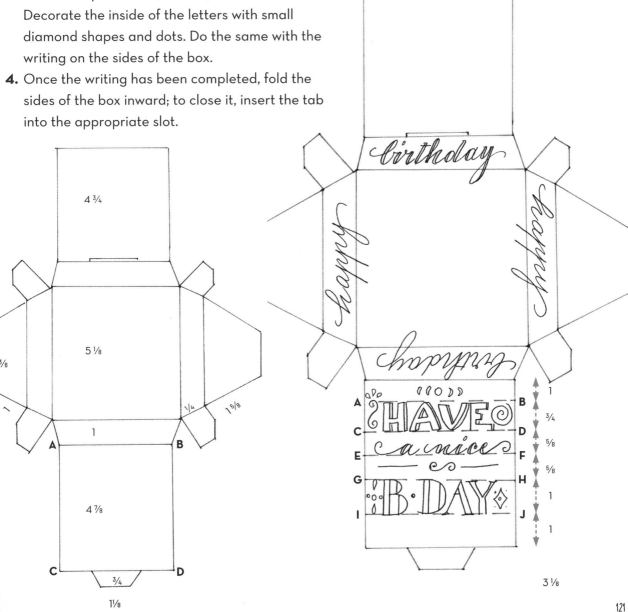

"TESORI" TREASURE BOX

1. Find a paper box in a natural color. The size of the box pictured is 9 ½ x 6 ¾ x 4 ⅝ inches (24 x 17 x 11.8 cm).

2. On a sheet of sketch paper, draw perimeter AEFI in pencil. This will represent the lid of the box, where you will trace the layout of your lettered design. Draw vertical lines BH, CG (the median), and DZ. Outside the perimeter, mark the points X and Y as illustrated in the template.

3. Place the needle of your compass on X and draw arc JL, tangent to line BD. Continuing to center the compass on X, trace arc KM, then draw line XY. Now place the compass needle on Y and trace arc RS, tangent to line HZ. Then, with the compass still centered on Y, draw arc NO. Then draw line PQ. Draw line TU.

4. Draw the outlines of the central letters so that letters S and O rest on line TU, while other letters will be arranged above and below it. Make the endings the flourishes on T and R stop at midline CG.

5. Write out the text in both the upper and lower arcs, including the broad strokes of the letters. Draw decorations to provide a border for the text. You can also draw a decoration inside the letter O.

6. In pencil, mark out all the measurements of the layout with the text onto the lid of the box. Outline the letters with a fine-point maroon marker, then fill them in using the same color. Decorate the inside of the strokes of "TESORI" with gold circles, which you can then fill with a fine-point white marker. Then use the fine-tip white marker to create decorations in and around the letters.

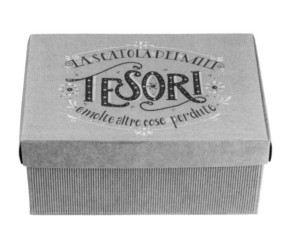
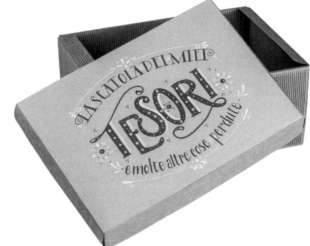

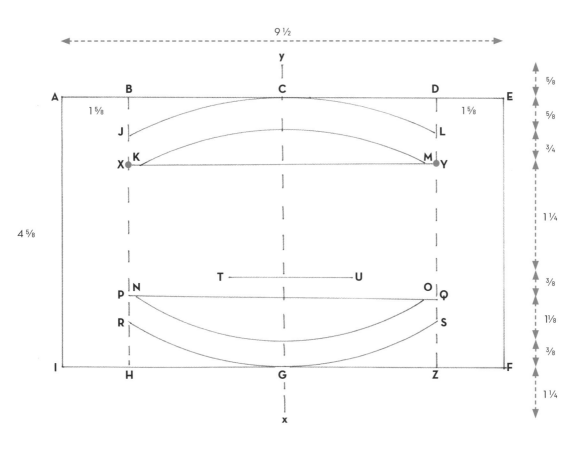

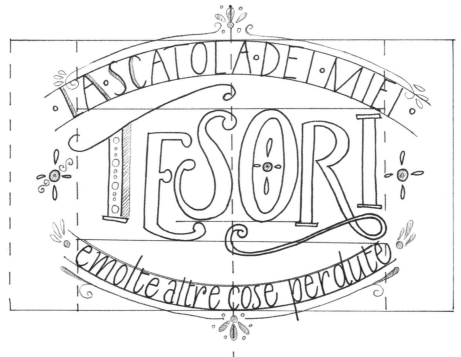

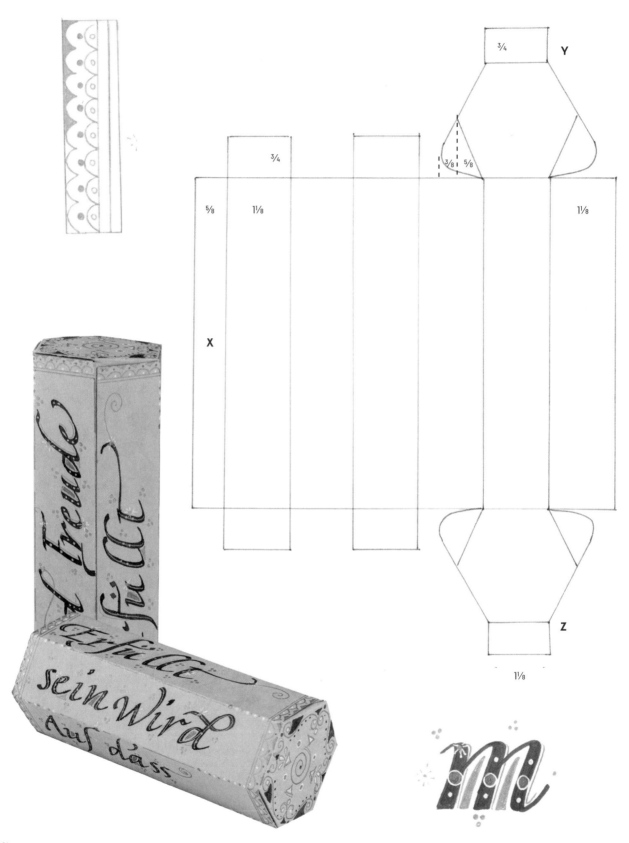

Y

3/4

3/8 5/8

3/4

5/8 1⅛

1⅛

X

1⅛

Z

1⅛

L Freude
zu All
Erfüllt
sein wird
auf dass

m

"LIEBE" BOX

1. On cardstock of a relatively uniform, natural color, draw the layout with the measurements shown in the template; cut it out along the edge.
2. Draw lines AB and CD. In each module, draw the guidelines EF and GH.
3. Write the text in pencil, marking out the thicknesses of different strokes. With a dark blue fine-point marker, trace the text and fill in the thicknesses.
4. In the bands along lines AB and CD, use gold and violet fine-point markers to create a decorative pattern.
5. Decorate the strokes of the letters with white and gold markers. Fill some of the arcs and counters with a light blue. Then decorate the lid of the box.
6. Fold all edges of the modules inward, taking care to maintain the hexagonal shape, gluing it together along module X. Insert the designated tabs to close the box above and below.

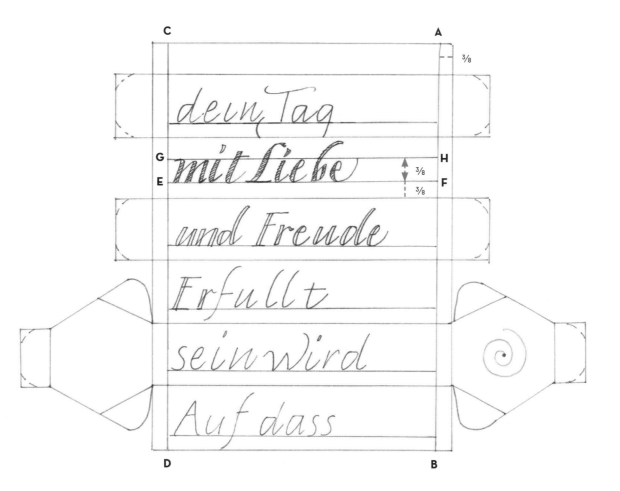

"DÍA ESPECIAL" BOX

1. Draw the diagram, with the measurements shown in the template, onto a sheet of cardstock of a consistent color, then cut it out along the edge.
2. Draw guidelines AB and CD on module X; write the text in pencil using a very narrow style of lettering.
3. With a brush, paint bands above and below the text with a light blue tempera paint, then let it dry.
4. Write out the text using a white fine-point marker, without worrying about the strokes being regular. With a gold medium-point marker, create a decorative spiral motif, finished with white dots at the spirals' ends. Then fill the spaces between the letters.
5. Once the lettering is finished, fold the sides of the box inward. To close it, glue it along module Y. Then fit the tabs together to close it above and below.

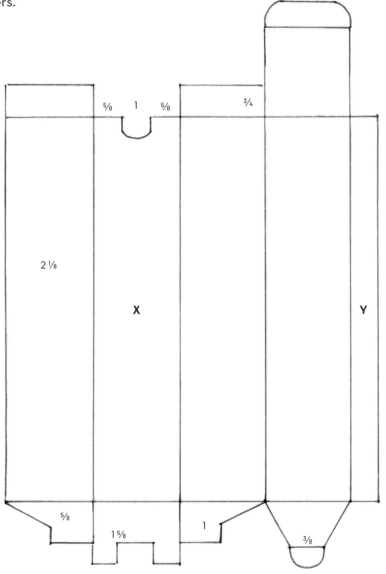

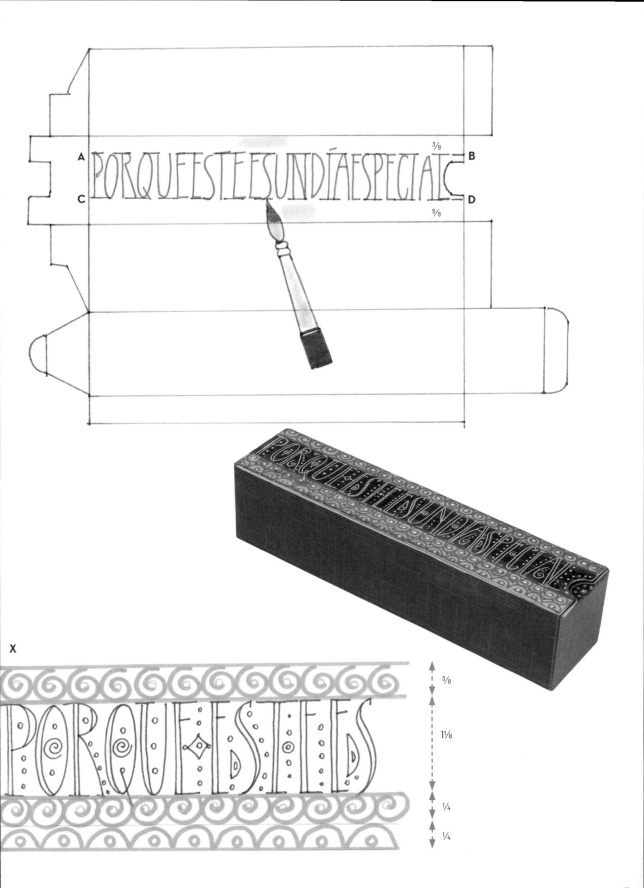

A · PORQUEESTEESUNDÍAESPECIAL · B

³⁄₈

C ⁵⁄₈ D

X

³⁄₈

1¹⁄₈

¹⁄₄

¹⁄₄

"MERCI" BOX

1. Find a square box in a natural color. The box pictured has 3 ⅞ inches (10 cm) sides.
2. Draw the median line, AB, onto the lid. Draw vertical lines CG, DH, EI, and FJ, then draw line KL and guidelines MN, OP, QR, and ST.
3. Open your compass 3 ½ inches (9 cm), place the needle on point B, and trace an arc above. Then, with the compass still centered on B, draw an arc below it. Draw the edges of the cartouche.
4. Write out the lettering inside the cartouche using a white fine-point marker, following its curvature, and mark the thickness of the strokes in the guidelines. Fill them with the same color. Draw decorations above and below the text using the same marker. Complete the design by writing the word "MERCI" on all sides.

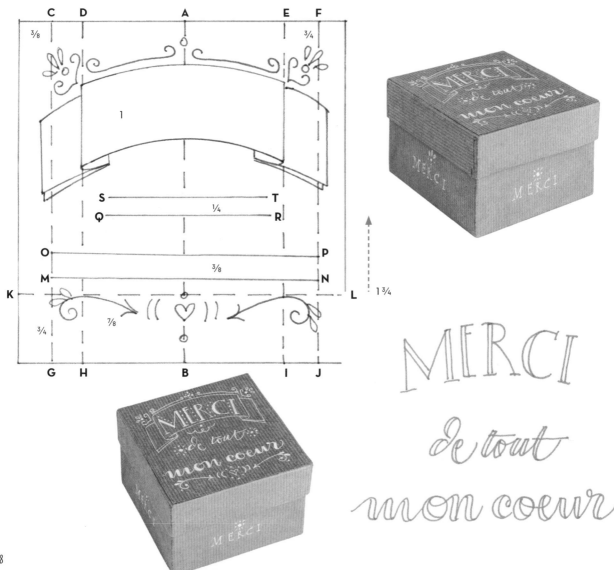

"LOVE" BOX

1. Find a small rectangular box (the box shown measures 4 ⅛ x 2 ½ x 1 ⅛ inches—10.5 x 6.5 x 3 cm).
2. Draw a straight line ⅜ inch (1 cm) from the edge of the lid and draw the outline with a pencil, taking care to round the corners.
3. Mark the guidelines as shown in the template and write the word "love" in a gentle script, staying within the lines.
4. Trace the text and the frame with a white fine-tip marker, embellishing it with small leaves and white and gold dots.

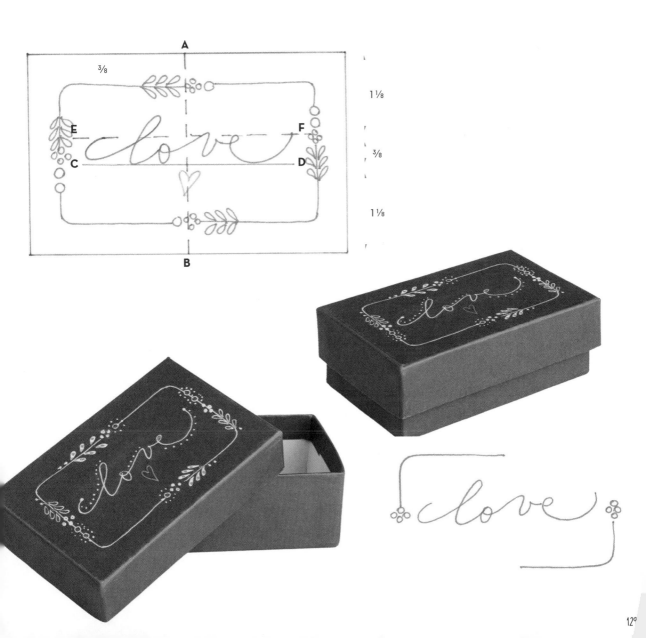

"DANKE" BOX

1. Get a small, square box. The example shown is 3 ½ inches square x 2 inches high (9 cm square and 5 cm high).

2. On the lid, draw vertical median AB, horizontal median HE, and diagonals DG and CF to find the center, then place the needle of the compass in the center, opened 1 ⅜ inches (3.5 cm), and draw a circle. Mark the guidelines as shown in the template.

3. Write out the text in pencil and draw a small heart on the lower guidelines. Write the text using pink and red fine-tip markers. Use a white marker to outline the heart, then fill it in with red marker. Trace the circle in white and embellish it with small leaves, circles, and dots of the same color.

4. Draw thin, decorative lines along all sides of the box.

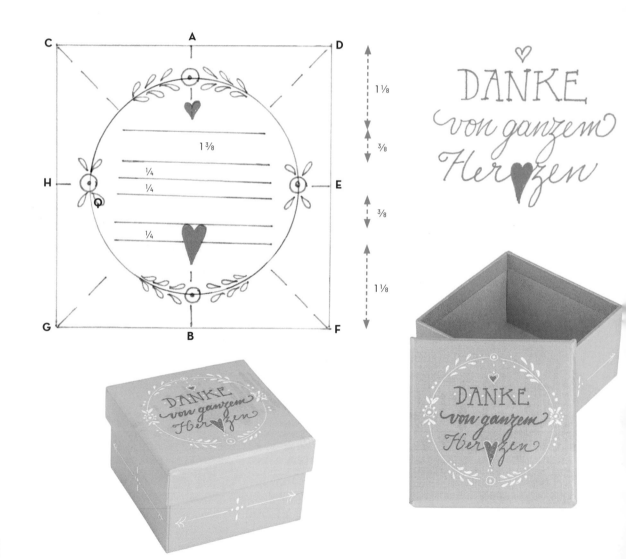

"PLAY" BOX

1. Find a box with an unusual shape and a natural color. The box that is pictured here is a flattened cylinder, measuring 4 ½ x ¾ x 2 ¾ inches (11.5 x 2 x 7 cm).
2. Mark out vertical midline AB onto the box and draw the guidelines.
3. Write the text in pencil, outlining the different widths of the strokes. Then trace all the words except "PLAY" with a black fine-point marker. Use a green fine-point marker to trace "PLAY." Fill the black-outlined letter strokes in black. Then fill the letters of "PLAY" in a bright green and add outlines using a white marker and decorate with white, dark green, and blue gel marker dots.

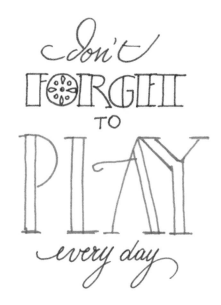

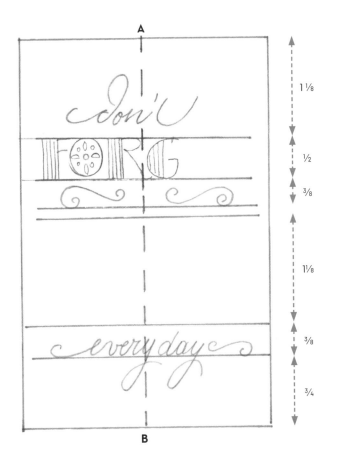

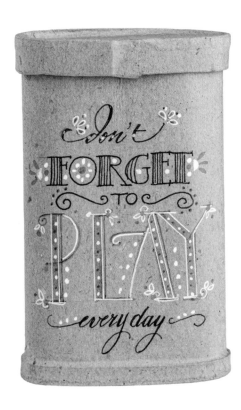

Greeting Cards

Greeting cards are always an excellent place to apply calligraphy and creative lettering. What could be better than receiving words designed and written exclusively for us, and to celebrate our best moments?

"SPÉCIAL" CARD

1. Find some cardstock in a solid color, white and green fine-point markers, and purple gel pens. Draw a square with 6 ⅛ inches (15.5 cm) sides on a sheet of sketch paper. This will be the size of your card.

2. Draw another square within the boundaries of the layout, shown here as a dotted line. Then draw the vertical median line, AB, and guidelines CD, EF, GH, IJ, KL, MN, OP, QR, and ST.

3. Write out the text in pencil, outlining the widths of the strokes. Once the text has been written out, draw an elegant, symmetrical border moving from point A to B on either side.

4. Transfer your layout to the cardstock with a pencil, including the lettering, writing out all of the words. Decorate the broad strokes of the word "SPÉCIAL," leaving some of the colored background of the cardstock and adding small touches of gold. Then complete the border with small leaves, hearts, circles, and other decorative elements.

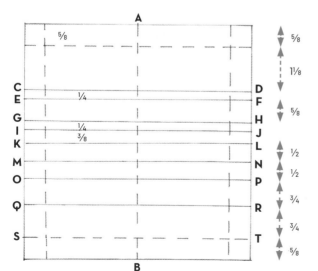

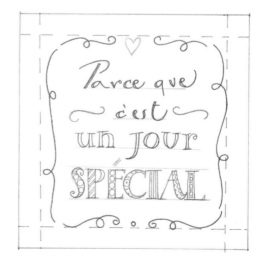

"DOUX" CARD

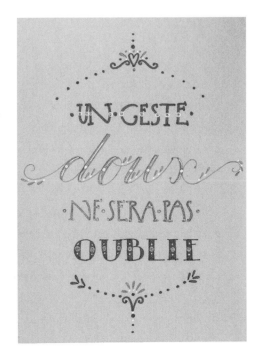

1. Get a piece of thick, colored cardstock and a medium-point burgundy gel pen, a fine-tip orange marker, a medium-point bronze gel pen, and a thin white one. Draw a 4 ⅞ x 6 ¾ inch (12.5 x 17 cm) rectangle on a sheet of sketch paper. This will be the size of your finished card.

2. Draw the vertical midline, AB; the horizontal midline, MN; lines CD and EF; and guidelines GH, IJ, KL, OP, QR, ST, and UV. Place the needle of a compass, opened 2 ⅜ inches (6 cm), on point X, the center of the layout. Draw an upper arc meeting line CD and a lower one meeting line EF.

3. Write the text in pencil in the guidelines, outlining the shape of the strokes. The word "doux" will occupy the entire width of the card.

4. Transfer the layout to your card with a pencil, together with the text. Write all the words and add embellishment to the upper and lower arches with dots and small decorative elements. Fill the strokes of the letters and add small touches for decoration.

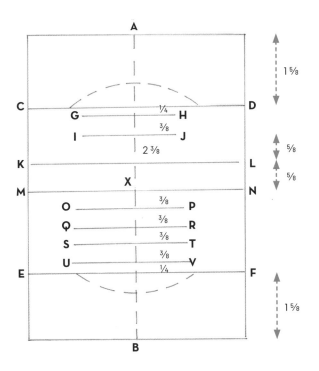

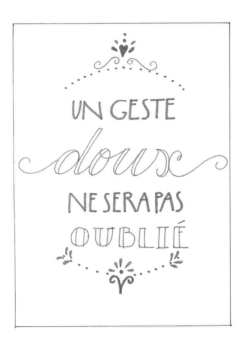

"PLAY" CARD

1. Find a piece of cardstock in a solid color, along with green, violet, blue, and white fine-point gel pens. Draw a square with 6 ⅛ inch (15.5 cm) sides onto a sheet of sketch paper. This will be the size of your card.

2. Draw the vertical midline, AB, and guidelines CD, EF, GH, IJ, KL, and MN. Draw lines QR and ST, which will provide a boundary for the drawing of a swing set. Place a compass needle on point X, where the median intersects with the guideline GH. With a 2 ½ inch (6.5 cm) opening, draw two small arcs as illustrated.

3. Draw two flourishes in the lower portion of the card, starting from line MN as shown, sloping slightly below line OP. Write out the text, marking out the width of the strokes and flourishes, then transfer the measurements in pencil to the cardstock.

4. Trace over the text with the gel pens, filling broad strokes and decorating them. Draw a small swing set in the space above, then embellish the flourishes with leaves, bees, and daisies. Finally, draw some blades of grass at the base of the word "PLAY."

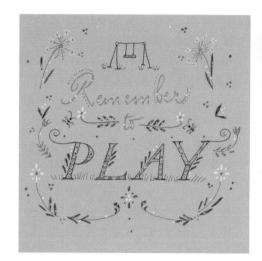

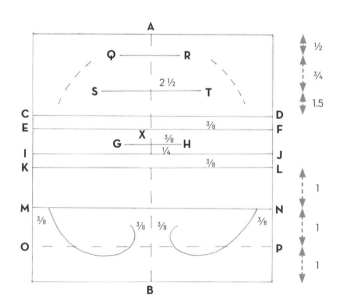

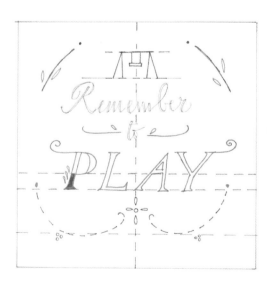

"RAINBOW" CARD

1. Gather together a thick piece of colored cardstock, a blue medium-point gel pen, a white fine-tip marker, ink, and a gold marker. Draw a rectangle measuring 8 ¼ x 4 ½ inches (21 x 11.5 cm) on a sheet of sketch paper. This will be the final size of your card. Draw horizontal midline AB; guidelines IJ, OP, EF, and KL; and guidelines MN and CD. Mark points G and H on upper and lower lines in the layout. Use these points to begin writing the words "SOMEWHERE" and "RAINBOW" respectively in pencil and marking the thicknesses.

2. When you have written all the text, write everything in pencil on the cardboard; fill the broad strokes and decorate with small white and gold motifs. Go over lines MN and CD with the gold marker, then make a stripe with the gold ink, and let it dry well.

3. When the gold is dry, write "Happy Birthday" with the white marker. Decorate the rest of the card with very thin spirals in white.

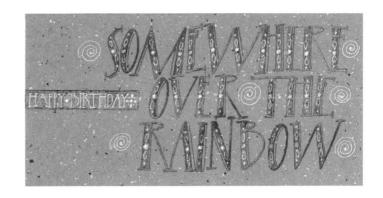

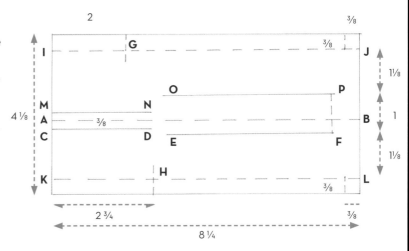

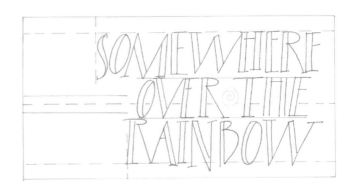

"BUON NATALE" CHRISTMAS CARD

1. Find some thick cream-colored cardstock. Gather black, light green and dark green fine-point markers, a gold marker, and a red gel pen. Draw a rectangle measuring 4 ½ x 6 ⅞ inches (11.5 x 17.5 cm) on a sheet of sketch paper. This will be the final size of your card.

2. Draw vertical median AB, trace line CD and guidelines EF, GH, IJ, and KL as in the template, and line OP.

3. Mark point X, where the median and line CD meet. Place a compass needle on point X with an opening of 1 ⅞ inches (4.7 cm) and draw a semicircle that touches line CD. With the compass still centered on X, draw a second semicircle. Draw two lines extending the semicircle to line OP.

4. On the median, measure ¾ inch (2 cm) beneath this arc. It is from this point you will begin the flourish, which will finish at line OP.

5. Write "BUON NATALE," outlining broad strokes in the letters. Then write it in italics along the inside of the arc, making sure that the text begins with "BUON" and ends with "NATALE."

6. Copy everything in pencil on the cardstock. Write the outline of "BUON NATALE" in dark green and decorate with black and light green. On the fine strokes of the letters, draw small golden leaves and some red dots.

7. Write inside the arc with light green, decorating with small red and gold dots.

8. Finally, trace the flourish with the gold marker, then decorate it with gold stars and red dots to make it look like a Christmas tree. Add a red heart to finish.

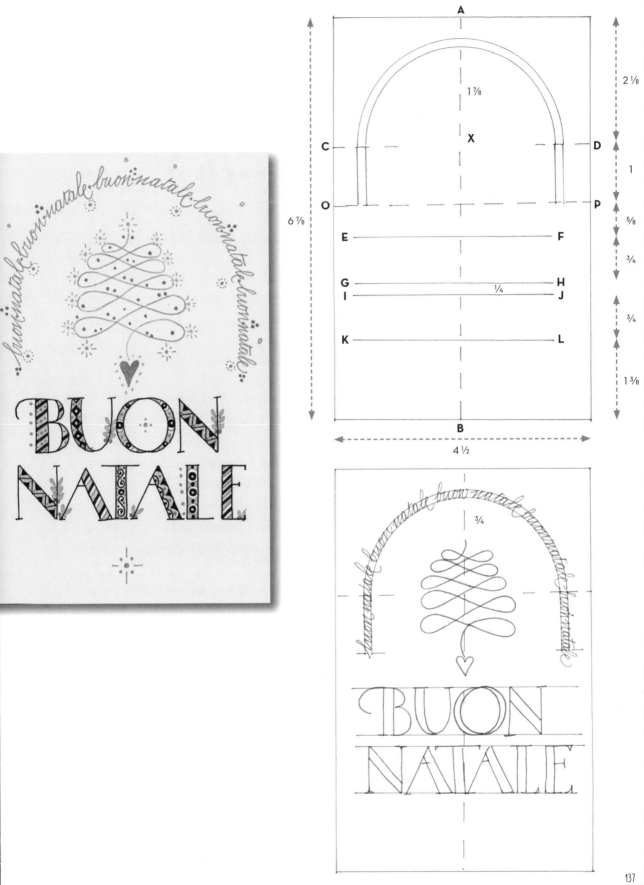

A

1⅞

2⅛

C X D

1

O P

5⅛

E F

3/4

G H
I 1/4 J

K L

3/4

6⅞

1⅜

B

4½

buon natale buon natale buon natale buon natale

3/4

BUON
NATALE

137

Christmas Calligrams

A calligram is, in effect, a decoration meant to astound and amaze. It therefore lends itself perfectly to making cards for Christmas!

TREE CALLIGRAM

1. On a piece of sketch paper, draw the layout in pencil (7 ⅞ x 5 ¾ inches / 20 x 14.5 cm). Draw vertical midline AB. Mark points C, D, E, and F. On the median line, mark point G. Center the compass, with a 5 ⅛ inch (13 cm) opening, on G and draw an arc reaching points E and F. Then, draw lines between points G and E, then between points G and F: you have created a border for the silhouette of your tree.

2. With the compass needle still on G, draw a series of arcs inside the cone shape, from the bottom to the top of the tree. The distance between arcs is about ⅜ inch (1 cm), except for the two lowest bands, which need to be wider, about ⅝ inch (1.5 cm).

3. Try several different ways to write the text inside the cone, marking out the thicknesses of the letters. In this case, words are arranged in alternating lines of text. Once the shape of the text has been defined, transfer the measurements in pencil to a rather thick, light-colored cardstock, laying out the lettering.

4. Using a pen with a pointed nib, begin writing the words using a burgundy ink; then clean the nib and write the rest of the text using gold ink. With a copper or bronze gel pen, fill the spaces between letters in the two lines at the bottom. Then, using a gold gel pen, fill the spaces between the other letters with dots of various sizes. You can use this layout to make many other kinds of trees. Finally, draw some lines in pencil starting from the upper edge of the card. You can then draw points, stars, and golden spirals along them.

5. When the ink is completely dry, erase all traces of pencil.

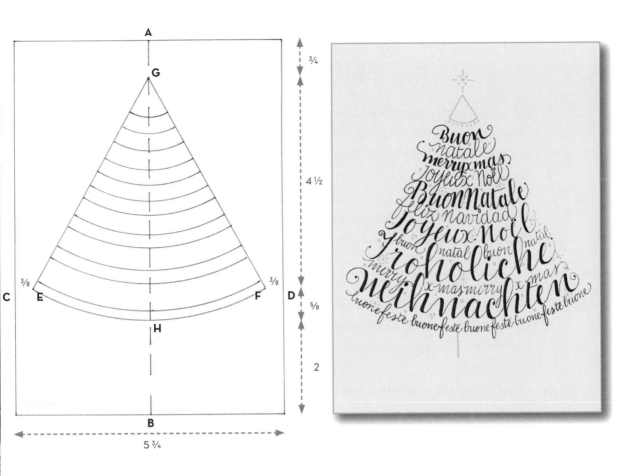

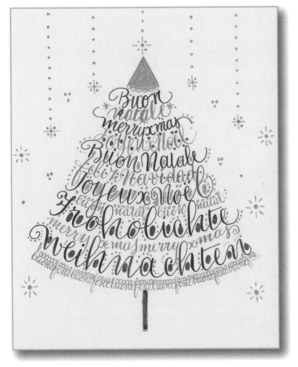

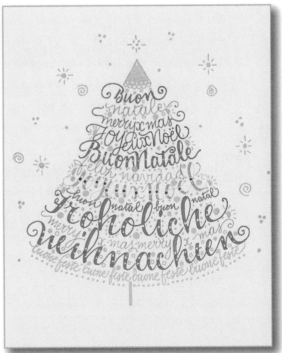

ANGEL CALLIGRAM

1. On some sketch paper, draw a rectangle measuring 5 ⅞ x 6 ¾ inches (15 x 17 cm) in pencil. This will be the size of your final card, in which you will position an angel taking up about 4 ⅞ x 5 ½ inches (12.5 x 14 cm) of the space.

2. Draw or trace the angel in pencil, tracing the irregular bands of the dress that will serve as your guidelines. The lowest band will be wider than the others, which will become gradually smaller as they near the angel's head.

3. Draw the guidelines on the wings.

4. Begin writing from the bottom band, marking the strokes of the letters; experiment on the rest of the dress with fine- and medium-point markers, alternating them on the guidelines to create movement.

5. Write the text on the wings with a medium-point marker; use a fine-point marker for her sleeve and hair, following the trend of the lines using very small letters.

6. Once the shape of the text has been defined, draw the angel on what will be your finished card.

7. Start writing from the bottom with a dark blue gel pen, drawing out different thicknesses in the strokes. You can color spaces between the letters in light blue, as illustrated.

8. Continue alternating medium- and fine-point gold and blue markers. Color the bodice using blue gel, then use the same color for the sleeve.

9. Write on the wings with a gold marker. Create the angel's hair with the gold gel pen, and use the same pen to make the trumpet.

10. Having finished writing, decorate the dress with gold and white dots, drawing lace on the sleeve and bottom of the dress. Don't be afraid to overdo it.

11. Draw the face, hands, and feet with the gold marker. Decorate the space around the angel with gold stars; when all the different inks are dry, erase the traces of pencil.

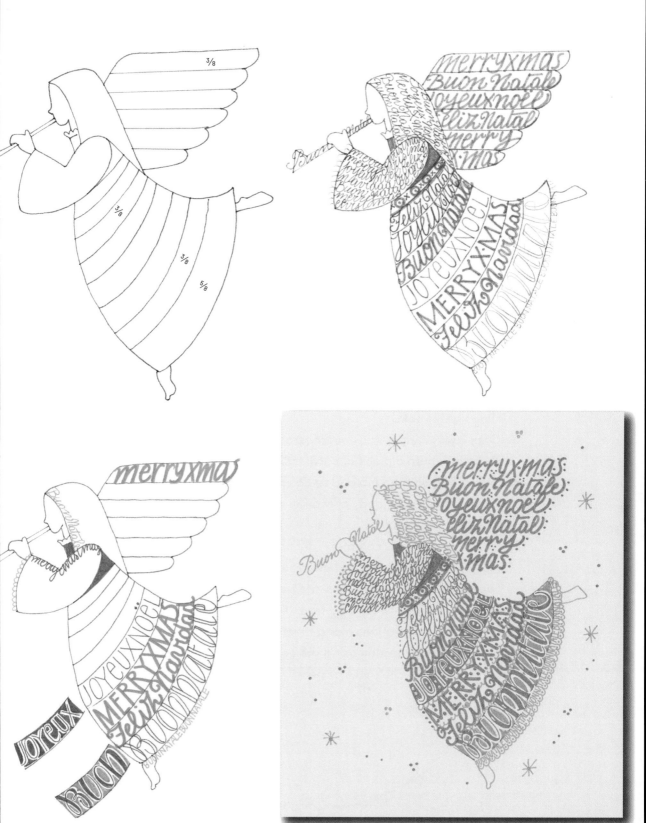

REINDEER CALLIGRAM

1. On some sketch paper, draw a 5 ⅜ x 7 ¼ inch (13.5 x 18.5 cm) rectangle in pencil; this will be the measure of your final card, in which you will position a reindeer that measures about 3 ⅛ x 4 ¾ inches (8 x 12 cm).

2. Draw the vertical median line, AB, and line CD, on which the reindeer will stand. Draw line EF, to use as a guideline for another greeting or decoration.

3. Draw or trace the reindeer in pencil, with bands for your guidelines.

4. Experiment with your lettering, using freeform italics to define the shape of the text.

5. Once everything is satisfactory, transfer the drawing and guidelines onto a piece of cardstock, and then add the text.

6. With a fine-pointed nib and red or burgundy ink, write out the words defining the body of the reindeer; use a fine-point gold marker for the antlers.

7. Once the writing is complete, define the reindeer's ears, hooves, and breastplate by filling them with burgundy ink. Decorate the breastplate with small white and gold circles.

8. Draw lines in pencil starting from the upper edge of the card, and draw small decorations along them.

9. Draw some decoration using the gold marker on line EF. When the ink is dry, erase all traces of pencil.

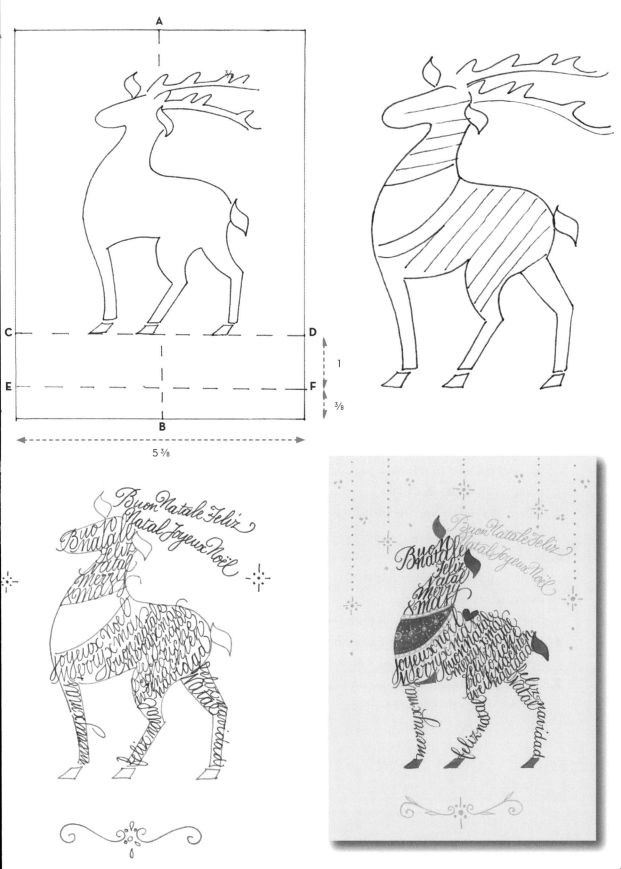

Cups and Mugs

Mugs with a decorative inscription are very popular. They can communicate a fun message and be used in all kinds of situations.

BEFORE YOU BEGIN

1. In order to decorate ceramic cups and glass, you will need special markers, which can be found in a good range of colors in specialty shops. These "paint pens" write on various surfaces. They are often called "permanent" markers, but the ink's resistance over time and washing is not unlimited. Always do several tests with multiple brands, until you find the kind that is most resistant. Taking care when cleaning the cup is also advised, as it will be more of a decorative item than something suitable for everyday use.

2. Before you write, clean the surface very well with denatured alcohol and avoid touching it with your bare hands. You can use thin latex gloves, which allow for good sensitivity.

3. In addition to the indelible markers, get yourself a couple of flexible rulers of different lengths: these are easily found in craft stores and are essential for taking measurements on curved surfaces. The procedure for transferring these measurements on the cup is the same for each example provided.

4. Write out the strokes to be traced on the cup with a very soft pencil or, better, with a normal fine-point marker, easily removable once the final version is finished.

5. In case of mistakes, use a cotton swab, moistened with a little alcohol. Wait for it to dry before starting to write again.

"LOVE" MUG

1. The cup pictured is 3 ½ inches (9 cm) high with a diameter of 3 ⅛ inches (8 cm).
2. Do some practice tests, then measure the guidelines and write the measurements onto the cup using the flexible ruler (B) and a very soft pencil or a fine-tip non-permanent marker. Then find a red fine-point permanent marker.
3. Check that the guidelines on the cup are straight and not too close to the handle.
4. Write the text, add decorations to the letters, then gently erase the guidelines (C).

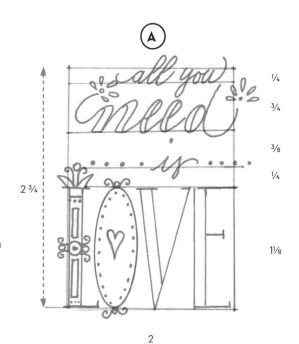

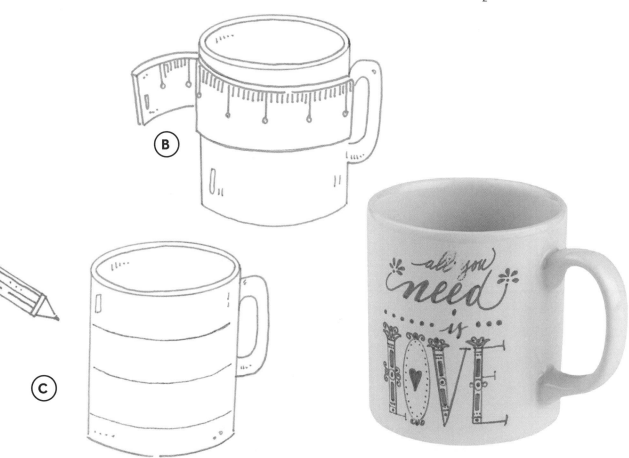

"PERFEKT" CUP

1. This cup is 3 ⅛ inches (8 cm) high with a 3 ½ inch (9 cm) diameter. On a sheet of sketch paper, write out the words in pencil, arranging them on two lines. Try to use an irregular and "imperfect" style, keeping the height of the characters even, about ⅝ inch (1.5 cm).
2. Make some experiments, then measure the guidelines. Write the measurements on the cup using a very soft pencil or a thin, impermanent marker. Find three fine-point permanent markers in orange, deep pink, and red.
3. Write the text on the guidelines with a fine-point marker, then trace it with the permanent markers, adding small decorations.

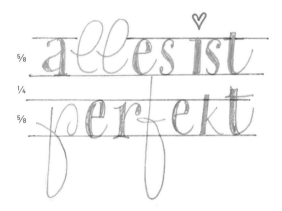

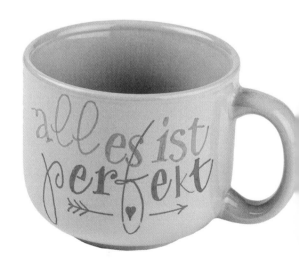

146

TEA INFUSER MUG

1. In this case, the mug is designed to steep tea and is 4 ½ inches (11.5 cm) high with a 3 inch (7.5 cm) diameter. Write the text onto some sketch paper, arranging it on three lines as shown (A). Following the measurements of the lid, mark a center point and place the compass on your sketch paper. Open it to the right size, then make a circle. Write your text along the circle, keeping the height of the writing slightly low.

2. Once you have done some practicing in pencil, transfer the measurements and text onto the mug (B). If you like, you can add other lines of text between the main lines (C). Find the center of the lid and cover it with two pieces of masking tape to keep the compass from slipping (D). Find some fine-tip permanent markers in green, orange, deep pink, and light pink.

3. Trace the writings onto the mug with permanent marker. Write on the lid, then embellish with decorations in a contrasting color.

A

B

C

Questo è
ein besonderer Tag
un giorno
un jour spécial
speciale
a special day

D

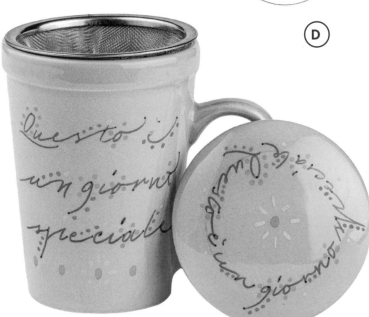

"PARFAIT" COFFEE CUP

1. This cheerful yellow mug is 3 ½ inches high and is 4 ½ inches in diameter (9 cm x 11.5 cm). The saucer has a diameter of 7 ½ inches (19 cm). Write out the letters in pencil on some sketch paper. Arrange it in four rows, with the first two to be written on the cup, then repeated and joined by the other lines on the saucer (A). Mark a center for the saucer and, with a compass open 2 ½ inches (6.5 cm), draw a circle onto the paper. Then draw a second circle, measured according to the height of your chosen lettering. Find a burgundy permanent marker and other markers with similar or contrasting colors.

2. Practice your lettering in pencil, with your hand rather free but keeping the height of the letters constant. Then transfer the measurements and writings onto the mug.

3. Look for the center of the saucer, and cover it with two pieces of masking tape to prevent the tip of the compass from slipping. Draw a circle as illustrated, then a second to contain the text (B), then write out the full text between them.

4. Fill the thick strokes of the letters with small polka dots. Add more decoration to the mug with spirals, circles, and dots all around the writing (C).

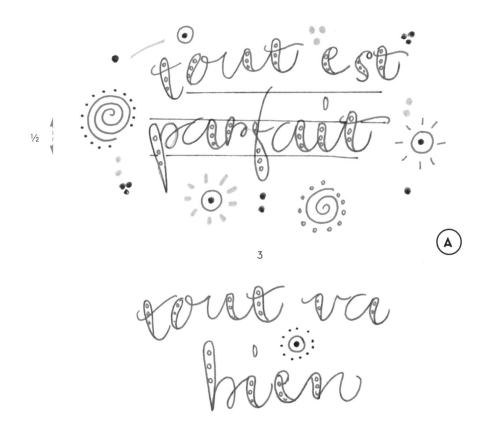

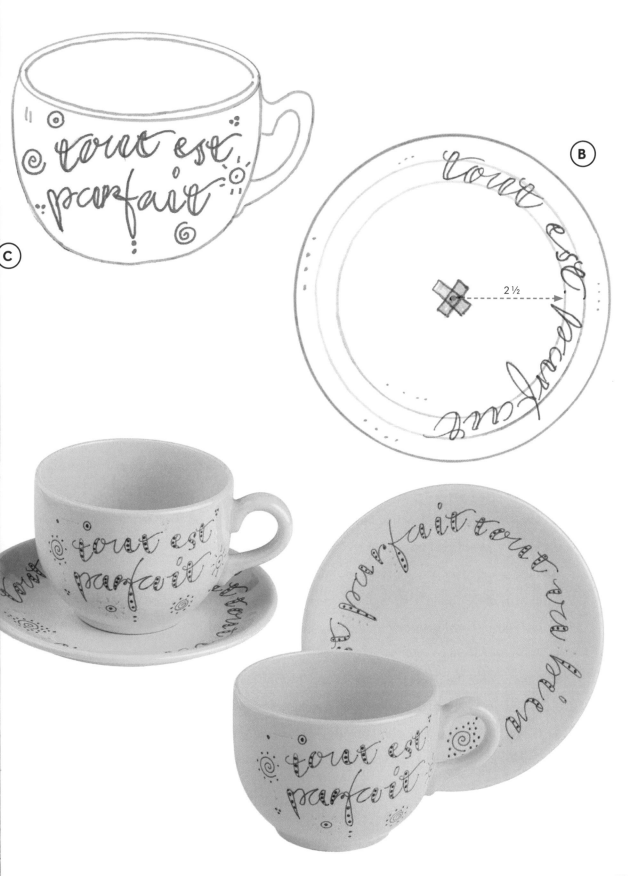

C

B

2 ½

Pillows

Cushions and throw pillows have always been a decorative staple in the home. They complete the décor and can be given as unique gifts on various occasions.

BEFORE YOU BEGIN

Find yourself some fabric markers: they are readily available at fine art and craft stores in various colors and widths. If you prefer, you can also use semiliquid fabric paint sold in glass jars, designed to be applied with a brush. These are very wash-resistant, even up to 60°C/140°F in the washing machine, and they stay bright over time.

1. Before you begin to write on your pillow cover, remember to wash it in order to remove any traces of starch that could prevent the correct absorption of paint; iron it well to remove any creases that could keep it from stretching nicely across the pillow.

2. Measure the cover and identify a layout that is proportionate to it: if there is a zipper, make sure that once the pillow or filler is placed inside the cover, the zipper will be positioned underneath the writing.

3. After making some practice tests, draw your final design on a white sheet, write your words in pencil, and go over everything with a black marker.

4. If the pillow cover is made of a dark, heavy fabric, write the measurements for the design directly onto it using a white tailor's pencil. You can write out the text correctly onto the material by copying from the sheet of paper with your draft of the dimensions, which you will keep in front of you.

5. If the color of the pillow cover is light and the fabric is lightweight, place your sheet of paper inside and trace the writing with a white tailor's pencil. If possible, you can also trace the text by placing the cover against a light source, inside a window frame, for example.

6. Once you have completed your lettering, iron the pillow cover, protecting it with a piece of cotton fabric to fix your paints.

The illustration shows some standard pillow measurements: you may find some that are similar to yours or make some adjustments, adapting the illustrated design to bring it into proportion.

"SUEÑOS" PILLOW

1. The dimensions of this pillow are 11 ¾ x 18 ⅛ inches (30 x 46 cm). Prepare the layout on a sheet of paper (A) and draw vertical midline AB. Inside the layout, trace guidelines CD, EF, GH, IJ, KL, and MN.
2. Write the text with a slightly irregular style; mark the thickness of the characters and the lines of the upper and lower flourishes (B), then trace them with a black marker. Gather some fine- and medium-point white fabric markers.
3. Draw the vertical center line of the pillow, line XY. Use a white tailor's pencil for this and to mark out the measurements of the layout. Make sure the distance from each side of the pillow is equal (C).
4. Holding the draft sheet in front of you, copy the text onto the cover with a tailor's pencil, again drawing the broad strokes and flourishes.
5. Fill in the thicknesses and complete with flourishes, scattered dots, and small strokes for decoration.
6. Once the paint has dried, iron the cover on the reverse side, protecting it with a piece of cotton fabric.

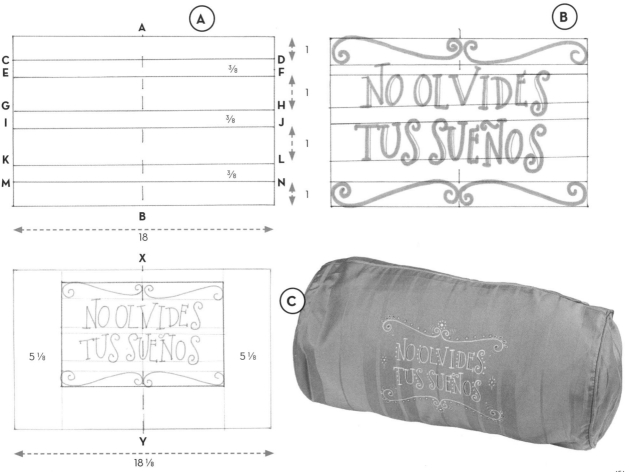

"KISSEN" PILLOW

1. The dimensions of this pillow are 16 ½ x 16 ½ inches (42 x 42 cm). Draw the layout onto a sheet of paper (A): draw vertical midline AB, then draw guidelines CD, EF, GH, IJ, KL, MN, OP, QR, and ST inside the layout.

2. Prepare the draft of your multi-styled lettering in pencil, taking care to keep the height of the characters constant within the curved guidelines. You can shift the guidelines above and below the wavy lines (B) slightly outside of the layout. Draw the thick strokes of the letters and the flourishes, maintaining a balanced whole. Then, trace everything with a black marker. Gather a white tailor's pencil and red, light pink, and white fabric markers, with medium- and fine-point tips.

3. Mark the vertical center line of the pillow, XY, using the tailor's pencil, then trace the measurements of the layout. Make sure the distance from each edge of the pillow is equal (C).

4. Copy the text of your draft onto the pillow cover with a tailor's pencil, including the widths of the strokes and flourishes. Trace with the colored fabric markers, fill the strokes with the colors you prefer, and decorate them with small touches of white and contrasting color.

5. When the paint is dry, iron the cover on the reverse side, protecting it with a piece of cotton fabric.

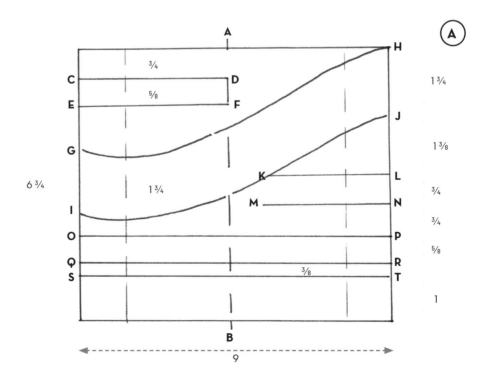

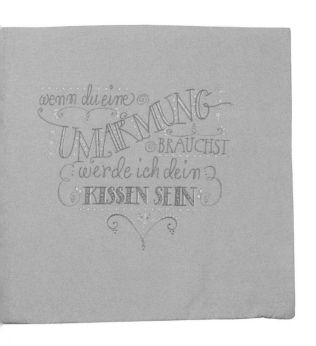

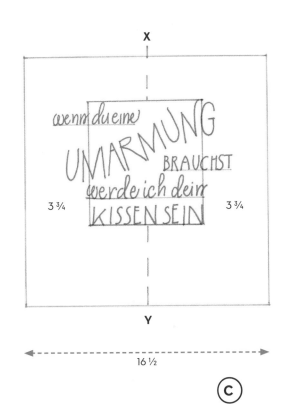

C

3 ¾ 3 ¾

16 ½

B

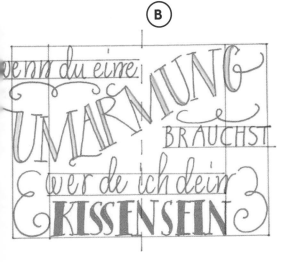

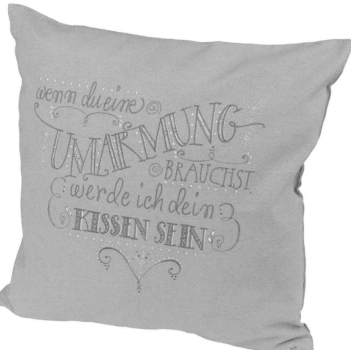

"MARE" PILLOW

1. The dimensions of this pillow are 24 ⅜ x 24 ⅜ inches (62 x 62 cm). Draw the layout in pencil on a sheet of sketch paper. Draw vertical midline AB and guidelines CD, EF, and GH (A).

2. Make several practice tests on paper, giving the writing a very spacious, wavy feel. Draw the broad strokes, then trace everything with a black marker. Gather some fabric markers in various shades of blue, both fine- and medium-tip.

3. On the pillow cover, draw a vertical center line, XY, and horizontal center line VW. Your layout will be positioned completely below line VW (B).

4. Copy the text of the draft onto the pillow cover with a blue pencil if the fabric is light or a white one if it is dark, including stroke widths and flourishes. Then fill the strokes with light blue (C).

5. If you like, you can embellish the design by writing this or another text, using a darker color with a more regular style and in a very small size, placing it above each line of the main text.

6. Decorate the top with a simple spiral, drawn with a fine-tip gold marker.

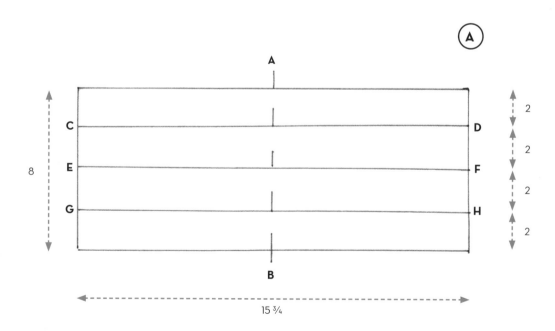

B

X
V — — — — W
Y

Metterei
il rumore
del mare
dentro ai cuscini

metterei
Metterei
il rumore
il ru more
del mare
del mare
dentro ai cuscini
dentro ai cuscini

C

Vases

Glass vases are indispensable elements for home furnishing, helping to decorate an environment and providing another field in which you can test your creativity. It is also easy to make something incredibly unique, using a verse from a famous poem or one of your own thoughts to make a special gift.

BEFORE YOU BEGIN

1. You can use specific glass markers, which you can find in a good range of colors in specialized shops. It is useful to know that though the markers for writing on glass, ceramics, plexiglass, and mirrors are called "permanent" markers, despite the name, their resistance over time and with washing is not infinite. Experiment with different brands of markers until you find the best. A great deal of care is also recommended when cleaning the glass.

2. Before writing on the glass, clean the surface very well with denatured alcohol and avoid touching it with your bare hands. You can use thin latex gloves, which still allow for sensitivity of touch.

3. To correct any errors, use a cotton swab wet with a little alcohol. Wait for it to dry before beginning to write again.

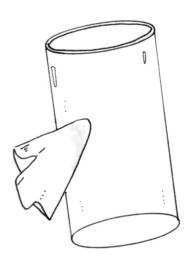
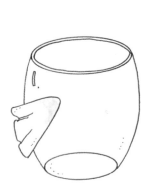

LARGE VASE

1. Choose a rather large cylindrical vase: the dimensions of the example shown here are 9 ½ inches high x 4 ¾ inches in diameter (24 x 12 cm). Clean the surface well with a cloth soaked in alcohol.

2. Choose your text and write it in pencil onto a sheet of paper, drawing guidelines at regular intervals. Go over it with a fine-point black marker, broadening only select strokes and maintaining a light, graceful feeling throughout (A).

3. Place the sheet inside the vase, keeping it a certain distance from the bottom and cutting it to size until it fits nicely along the sides (B); secure it with pieces of tape to prevent it from moving, and adjust it until the guidelines are straight on the vessel. With a black permanent marker, trace the text and outlined strokes, then fill them in with black (C).

4. Once finished, remove the sheet and clean the inside of any traces of tape with a little alcohol.

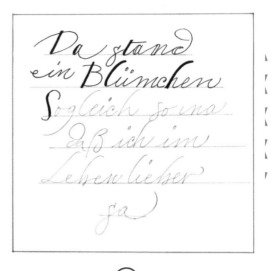

(A)

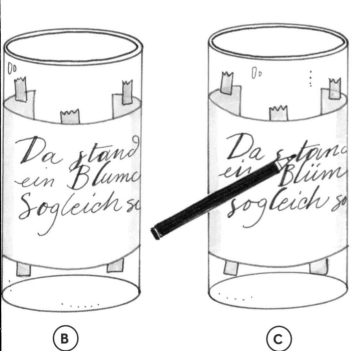

(B) (C)

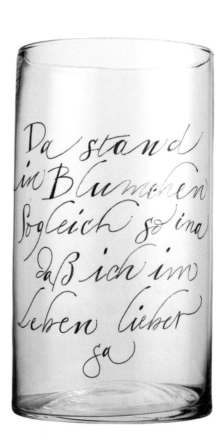

MEDIUM VASE

1. Select a medium-sized vase: the one shown here is 5 ⅛ x 4 ⅜ inches in diameter (13 x 11 cm). Clean the surface well with a cloth soaked in alcohol.

2. Write the guidelines and text in pencil on a sheet of paper. The width of the layout in this case is determined by the length of the word "IMPORTAN." Create a small border with simple decorations. Then go over the text with a black fine-point marker, building up the broad strokes (A).

3. Cut the sheet to size and place it inside the vase so it sits against the sides (B). Secure it with pieces of tape to prevent it from moving. With a permanent black fine-point marker, trace the text and decorations (C).

4. Once this is complete, remove the paper and clean any traces of tape inside with some alcohol.

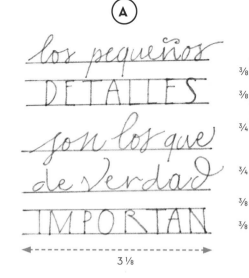

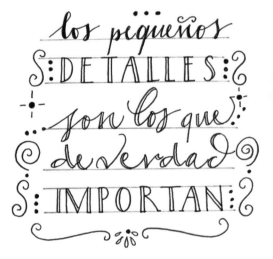

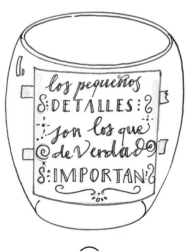

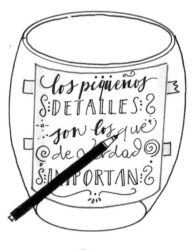

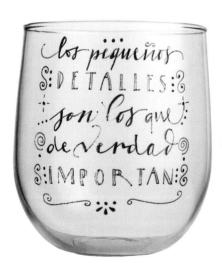

THIN VASE

1. Select a tall, thin vase: the one shown here measures 11 ¾ x 2 ⅜ inches in diameter (30 x 6 cm). Clean the surface well with a cloth soaked in alcohol.
2. Choose your text and write it in pencil on a sheet of paper in one or two lines. Trace with a black fine-point marker (A).
3. Place the sheet inside the vase, cut it to size so that it fits against the sides, then secure it with pieces of tape to prevent it from moving. With a red, fine-tip permanent marker, trace the letters and outlined broad strokes, then fill them with a medium red permanent marker (C).
4. Finally, remove the sheet of paper and clean any traces of tape from the inside with a little alcohol (D).

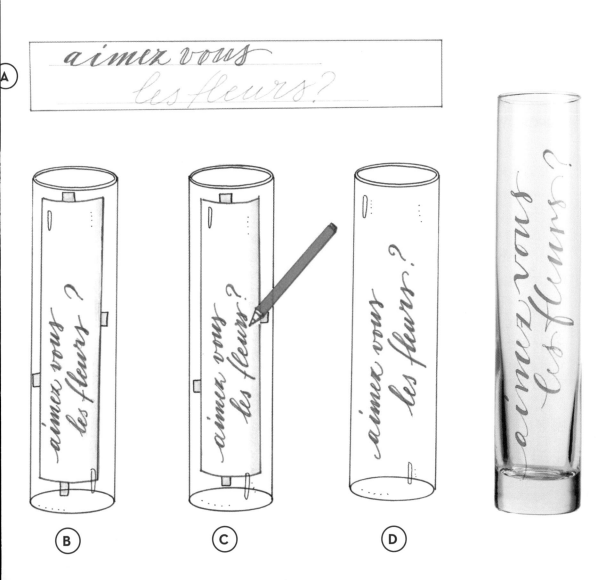

Decorative Pendants

Making original pendants is always very satisfying, for its own sake and for creating unique, special gifts.

To make the medallions that are pictured, Das modeling clay was used, with which you can produce small, lovely objects quickly and with versatility. There are other types of modeling clay on the market, like Fimo and Cernit, that are similar to Das. Das is sold in blocks and has the advantage of air-hardening rather than needing to be baked. Once dry, it can be decorated with tempera and acrylics, and made shiny using the right paint. You can also find colored options.

BEFORE YOU BEGIN

1. Modeling clay does not require any special manual skill and is easily molded. You do need to make your shapes relatively quickly to prevent it from drying too much while working with it, and be sure to close the bag with an airtight seal once it has been opened.
2. Use a clean cardboard or plastic surface for a support, which can be thrown away or washed. At first, do not take out an excessive amount of modeling clay, as you risk wasting it.
3. Find a knife to cut the excess clay and some cookie cutters of various shapes, like a square, circle, or heart. It is important to be sure that the pendant will have a uniform thickness. Find yourself a small rolling pin or a glass jar in order to achieve a good result.
4. To write on or color the pendant, you can use permanent markers, tempera, and acrylic colors.
5. If you have to interrupt the process, it will be enough to wrap the piece in cling wrap to keep it soft.

"INFINITO" PENDANT

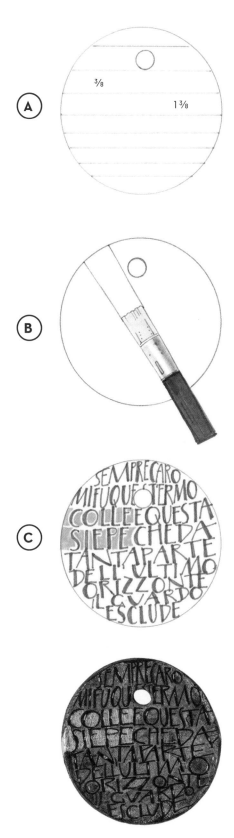

1. On a sheet of paper, draw a circle using a round cookie cutter approximately the size of the model. Still on the paper, draw the guidelines for the text inside the circle, with a spacing of about ⅜ inch (1 cm); the guidelines can be closer together at the top and bottom (A).

2. Write the text in pencil on the paper. Allow more space around the words "COLLE" and "SIEPE." Be sure that the first verse of Giacomo Leopardi's "L'infinito" is completely contained.

3. Take the modeling clay and work it a little, making a square shape with a thickness of about 3 mm that is large enough for the cutter. When you have reached a uniform thickness, cut out a round shape with the cookie cutter. Cut off the excess clay with a knife, and make a hole using a pencil or a plastic pen cap, then let it dry. When the medallion is completely dry, color it using a very light sepia tempera. You can glaze it, adding two or three coats (B).

4. Once the paint has dried, put the guidelines on the medallion and write the text using a sepia fine-tip permanent marker. Build up the width of the letters, then with gold paint or a gold marker, color the space around the words "COLLE" and "SIEPE" to add some shine (C). Add small points of light to the strokes of the letters as well, using a white fine-point marker. To finish, apply a coat of transparent varnish and let it dry.

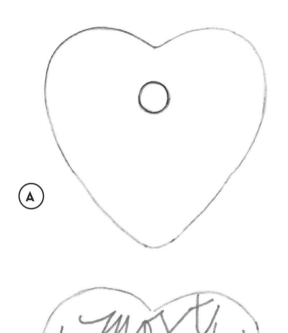

(A)

(B)

HEART PENDANT

1. Find a medium-sized heart-shaped cookie cutter (A), pink, red, and orange markers, and a fine paintbrush with tempera paints in the same shades. On a sheet of paper, trace the outline of the cookie cutter and write the words inside, without the help of guidelines (B).

2. Roll out a square of modeling clay that is large enough to fit the cookie cutter and check its thickness, which should be about ¼ inch (5–7 mm).

3. Use the cutter on the clay, cutting away the excess, then make a hole with a pencil or a plastic pen cap and let it dry. Once the modeling clay is dry, write out the text using a fine-tip pink or red marker, copying it from the draft you have prepared (C).

4. With a thin brush and tempera paint, create dots of color around the writings, taking care not to cover them and to leave some white space (D).

5. Allow the color to dry, and finish with a coat of clear varnish.

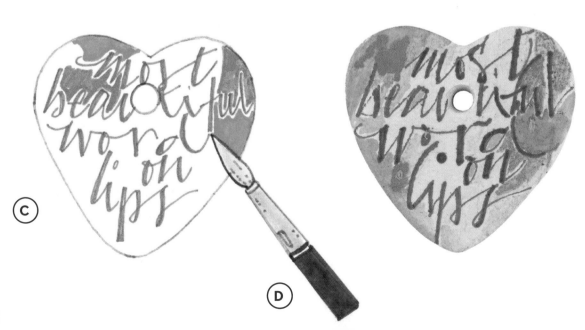

(C)

(D)

"M" PENDANT

1. Find some terracotta-colored modeling clay and work it into a square that will fit a cookie cutter of the size shown (A). It can be about ⅜ inch (8 mm) thick.

2. Cut out the round shape using the cookie cutter, cut away any excess modeling clay with a knife, then make a hole with a pencil or a plastic pen cap. Let it dry.

3. Prepare a draft in pencil on a sheet of paper, drawing the central letter "m," writing along the border and taking care that the ends of the phrases surround the horizontal diameter of the circle (B).

4. Transfer your design onto the pendant, outlining the letter "m" with a fine-point black marker, then filling it in. Trace the rest of the text with a black or white fine-tip marker (C) and add some shine with dots of copper-colored marker on the "m."

5. Apply a coat of clear varnish.

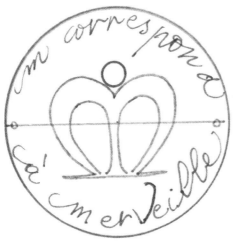

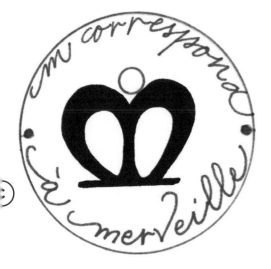

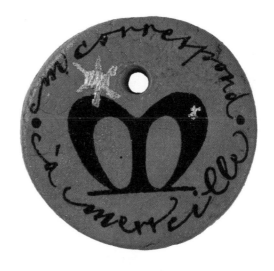

CAT TAG

(A)

3 ⅛

5/8

3/8

3/8

3/8

3/8

3/8

½

1 ⅜

1. Cut out a rectangular tile about ⅛ inch (2–3 mm) thick. Round the corners and make a hole with a pencil or plastic pen cap; let it dry (A).
2. When it is dry, place the tag on a sheet of paper and draw the outline in pencil; draw the guidelines inside as shown in the template, and write the text using a very slim, even style of lettering, using a more rounded letter "o." Color the dried tile with a semi-transparent, warm-colored tempera, then let it dry (B).
3. When the paint is dry, draw the guidelines in pencil and write the text using an orange fine-point marker. With a gold marker or paint, fill the inside of the larger "o" letters to create some shine (C).
4. Complete with a flourish at the bottom and strokes resembling a cat's whiskers around the hole. Finish with a coat of clear varnish.

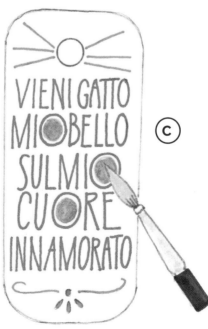

(B)

VIENI GATTO
MIO BELLO
SUL MIO
CUORE
INNAMORATO

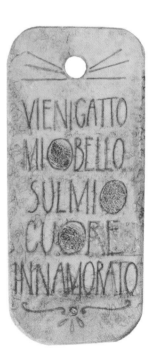

(C)

VIENI GATTO
MIO BELLO
SUL MIO
CUORE
INNAMORATO

"HOPE" TAGS

1. Cut out two modeling clay rectangles in the sizes illustrated (A and B), with a thickness of about ⅛ inch (3 mm). Make a hole in each with a pencil or plastic pen cap, making sure it is placed at the same height on each tag. Let them dry.

2. On a sheet of paper, prepare a draft in pencil, writing one part of a chosen phrase on each tag.

3. Now write it on the dried tiles using a dark marker, decorating around the words using fine lines. When the tiles overlap, the result should look like the illustration to the right (C). Finish the tiles with a coat of clear varnish.

4. Once the varnish is dry, assemble the two pieces with a shoestring, so the entire sentence can be read as they move (D).

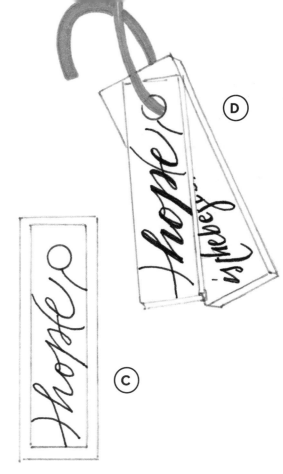

D

C

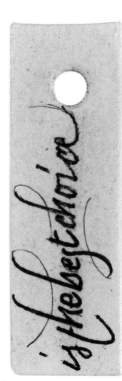

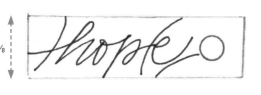

A

⅝

2 ⅜

B

¾

2 ½

Exercises

On the following pages, you will find a series of easy and very useful exercises to loosen your hand, from a series of simple scribbles to more rigorous exercises for gaining control of the fine- and broad-tip pens.

Most of the strokes presented in this section, beyond the structural function of the characters, can be used to create decorative motifs to embellish your works.

You can use 60 g/m² (16 lb) sketch paper for writing (like Favini, Fabriano), or, since you will be throwing away several sheets of paper (especially when just starting), you can use white and brown gift-wrapping paper as long as it is not too porous. Otherwise, your strokes will be poorly defined and smudged, and the result could be very frustrating.

Try as many kinds of paper as you can. One always benefits from following this rule, even when you feel very confident with the pen and move on to completing final compositions.

Loosening Your Hand

To loosen your hand and get started with a blank sheet, draw some guidelines and, with a medium-point marker, make these strokes with a single gesture. Before starting, you can follow the stroke while holding the pen suspended above it in order to understand what movement to make, following the ductus.

Repeat the strokes several times, attempting to trace them with certainty and to make them as similar to each other as possible.

Prior to performing each exercise, try to draw the series of marks freely and somewhat quickly, and examine the result.

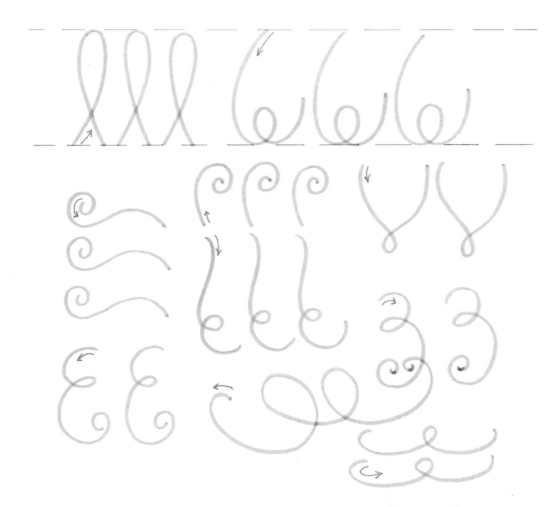

Now focus, and:

1. Draw a series of fairly long vertical lines, keeping them parallel, with a constant space between them; you can alternate between a medium-point and a fine-tip marker.
2. With the same tools, draw a series of strokes with a small point in the middle.
3. Repeat the exercise, this time with a fairly wide, wavy line.

Finally, compare the strokes with the ones you drew at the beginning.

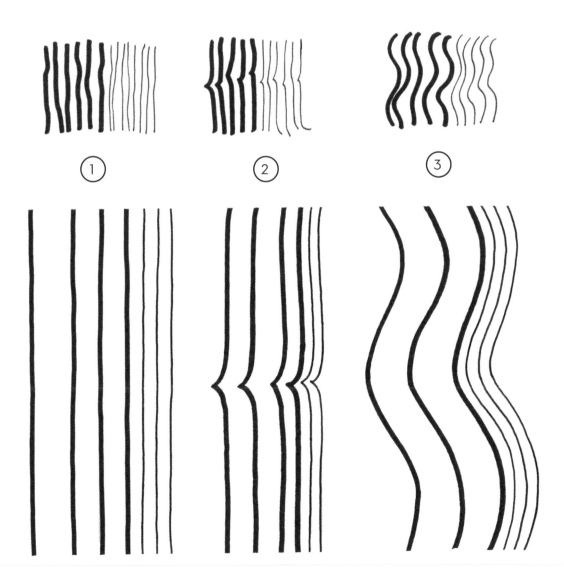

We begin a series of "doodles" with a seemingly simple shape, like a circle.

1. With a medium-point marker, draw a fairly large circle using several quick strokes.
2. Make the strokes so they are compact, until you have an even, regular circle.
3. Try varying the speed of your gesture a few times, until you reach a satisfying result.

1. With a medium-point marker, quickly draw a large flower with eight petals and take a look at the result.
2. With a compass, draw a circumference the size of your hand-drawn flower; mark vertical and horizontal axes of the circle. With a pencil, slowly draw the first four petals as shown.
3. Draw diagonal axes, then draw another four petals. Repeat this exercise several times.
4. Finally, without the help of the circle drawn with the compass and having committed the movements to memory, try to draw the flower again.

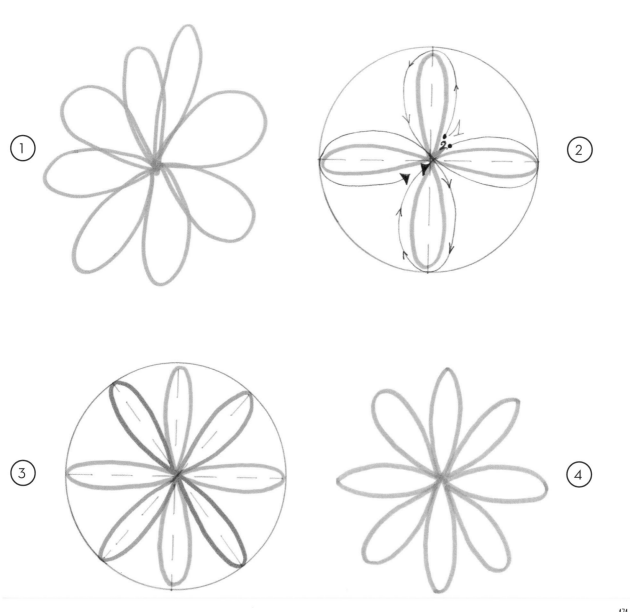

1. Draw a freehand corkscrew shape and examine the result.
2. Draw guidelines and draw the corkscrew again, making sure that the loops are regular and perpendicular to the guidelines, with a constant rhythm.
3. Draw a rather large teardrop shape in pencil; trace a corkscrew inside, filling the volume of the shape without losing the rhythm.

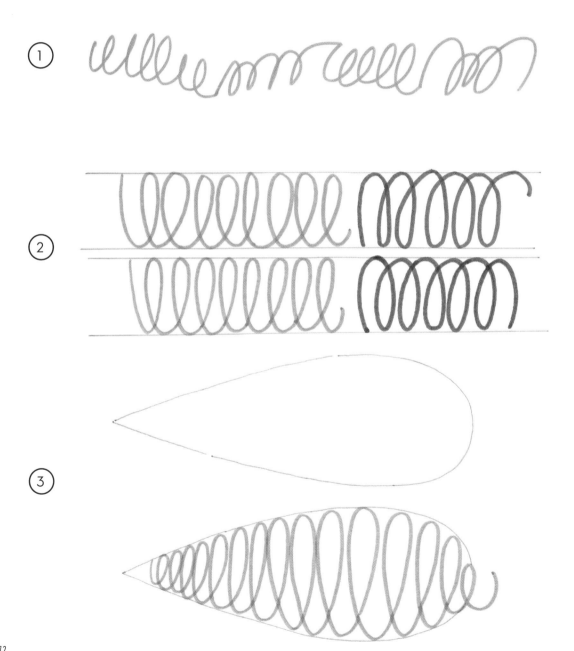

1. Quickly draw a very simple flourish with a figure 8 shape. Look at your result.
2. In pencil, draw a small grid with the proportions of your freehand flourish in length and height, then mark the axes. Draw the figure inside the layout several times, and when you have the movement memorized, draw one outside of it and take a look at the result.
3. Now draw a layout in pencil like the one illustrated, with guidelines arranged at a regular distance. Calmly trace the flourish inside the grid, observing how the strokes are arranged and maintaining the parallelism between oblique sections.

Repeat the exercise several times, then try to draw one outside the grid.

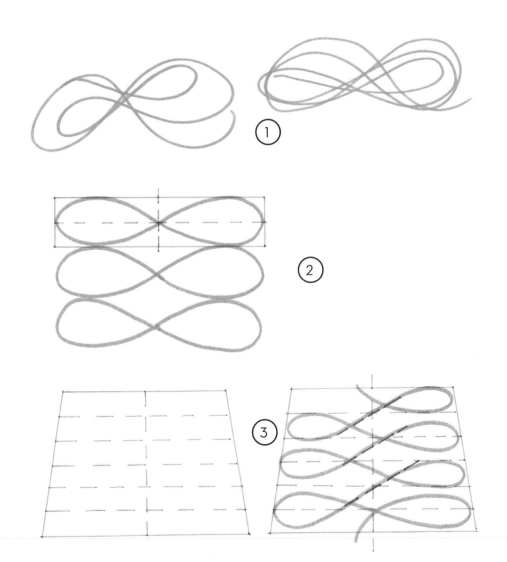

1. Using a medium-point marker, draw a scalloped border with a floral pattern at regular intervals.
2. Draw the guidelines, then draw semicircles on the upper guideline at regular intervals using a compass. Begin by drawing the pattern of the petals and join them with a curved stroke as illustrated.
3. Repeat this several times with the help of the guidelines using a medium-point marker.
4. Finally, try to draw the border without any guidelines.

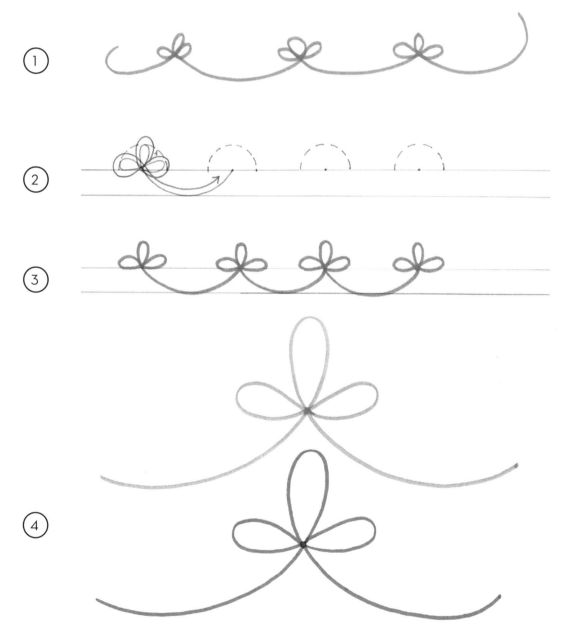

1. Quickly draw a spiral with a medium-point marker.
2. Draw a square grid the size of the spiral you just drew, marking the vertical and horizontal median axes. Mark out points on the axes at a regular distance.
3. Start drawing the spiral from the center of the square, taking care that the coils are kept regular using the points on the vertical and horizontal axes.
4. Repeat several times, then finally draw the spiral without using the grid.

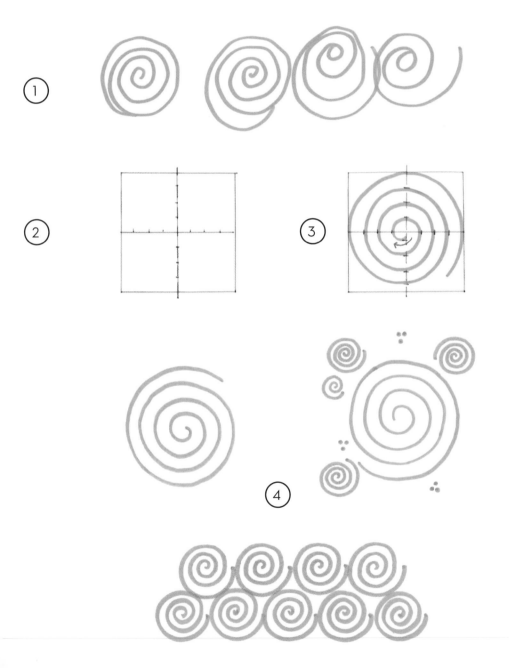

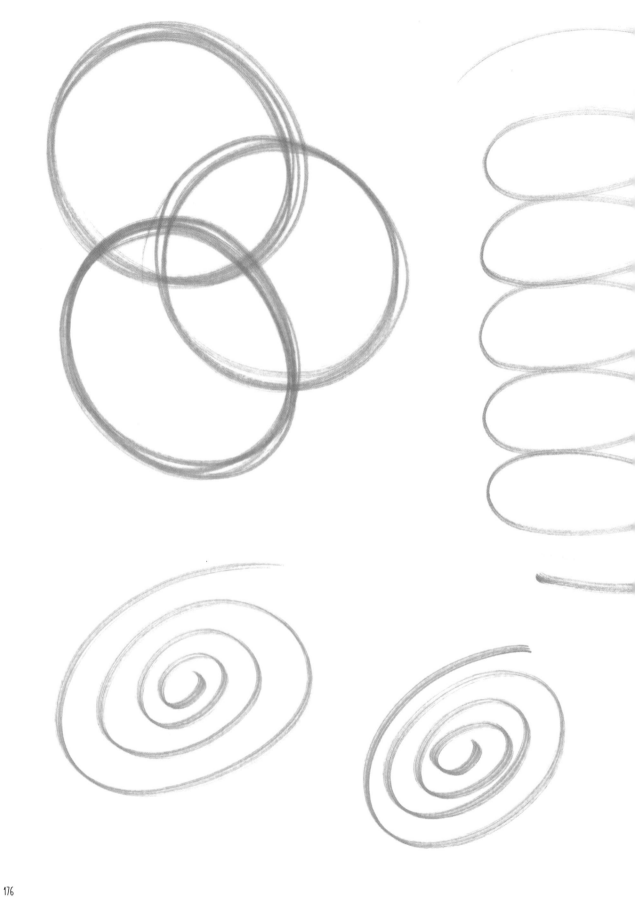

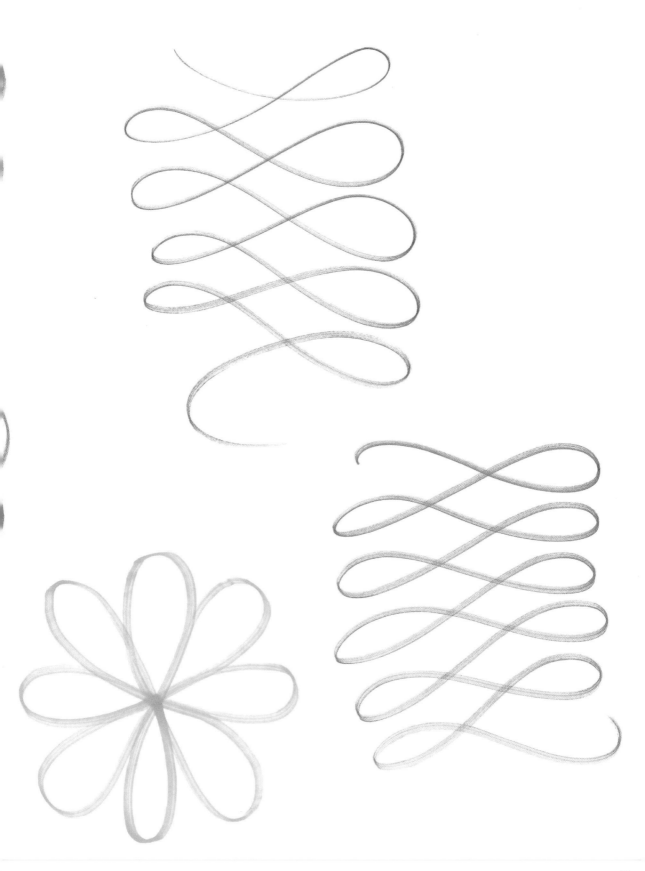

Exercises Using a Broad-edge Nib

Correctly using a pen with a broad-edge nib (also known as a chisel nib) requires some practice, especially since it is quite a different instrument from the pens we use on an everyday basis.

This section presents a series of exercises that will help you understand how to use a broad-nib pen and at what angle the nib should be placed on the paper. One of the greatest difficulties for people beginning to write with a broad-edge nib is managing to keep the angle constant.

Keeping the nib at the correct angle not only makes writing easier, but it is essential for your lettering to have uniform proportions.

For this reason, once you have chosen a letter style with a defined angle, the inclination of the nib must never be varied, whatever stroke you are making, apart from the exceptions mentioned.

What you need

pencil and eraser – ruler – 90°-45°-45° triangle – 30°-60°-90° triangle – broad-edge nib and pen holder – black ink – calligraphy markers – parallel pen

MITCHELL NIBS are among those used most by calligraphers for the precision of their stroke. They must be inserted into a pen holder and heated over a flame to remove the protective film coating them; after a few seconds, when the steel has become dark, the nib is then dipped in cold water and dried with a cloth.

A pronged metal reservoir can be attached to regulate the flow of the ink. It is attached to the underside of the nib, a couple of millimeters from the tip, neither too near nor too far from it. The space between the tines of the nib should not be open. To fill it with ink, use a fine brush to deposit the right amount of ink in the reservoir. After use, the nib should be washed with cold water and dried well.

PARALLEL PENS, which come in four sizes, are very practical because they are refilled via cartridge and allow you to make a clear, precise stroke.

These pens are very useful for preparatory stages and are available in many colors.

Now, let's begin with some simple exercises.

1. With a ruler, draw guidelines about ¾ inch (2 cm) high. Using a 90°-45°-45° triangle, draw a series of pencil strokes on the guidelines at a 45-degree angle, at intervals of ¼ inch (⅔ cm), as illustrated.
2. Placing the broad tip to the paper at a 45-degree angle, draw a series of zigzag strokes, keeping the angle of the nib constant for both thick and thin strokes, maintaining a sense of rhythm in your writing. Repeat this exercise several times; you can draw strokes one at a time, removing your pen from the paper, or one after another, though this requires greater control.
3. When you get tired of this exercise, you can repeat it using colored inks.

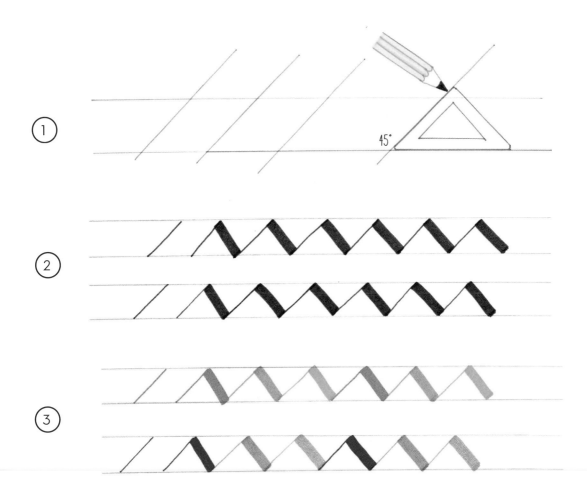

1. Repeat this series of exercises, this time using a 30°-60°-90° triangle: draw the guidelines and pencil strokes at a 30-degree angle.
2. Draw a zigzag, keeping the rhythm and incline of the pen constant, as in the previous exercise, and observe the differences between the two angles.
3. Repeat until the pattern is consistent.

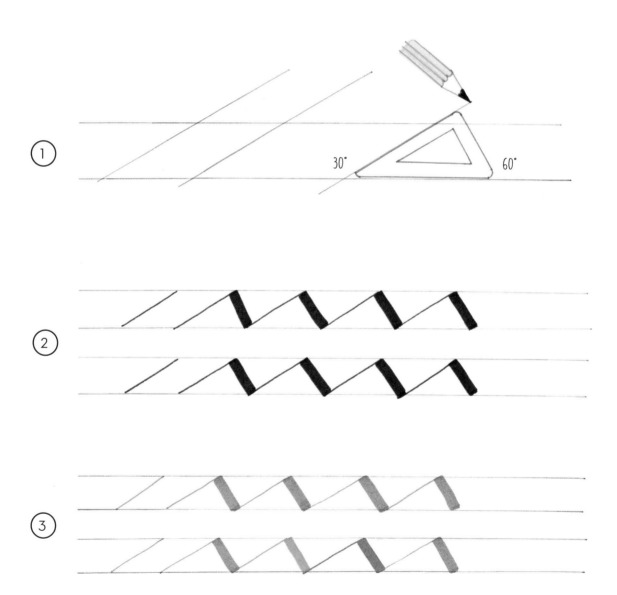

1. Now that you have learned how to prepare an exercise sheet and have begun to understand how a pen with a broad nib works, draw a series of vertical and horizontal strokes crossing each other, first at 30 and then at 45 degrees.
2. You can move on to slightly more complex shapes, like these softer oblique strokes or crescents, by trying both 30- and 45-degree angles.
3. Using the structure of Roman capital letters, write the entire alphabet with the nib at a 30-degree angle.
4. Do the same exercise using chancery capital letters with a pen angle of 45 degrees.
5. Note the differences between the different angles.

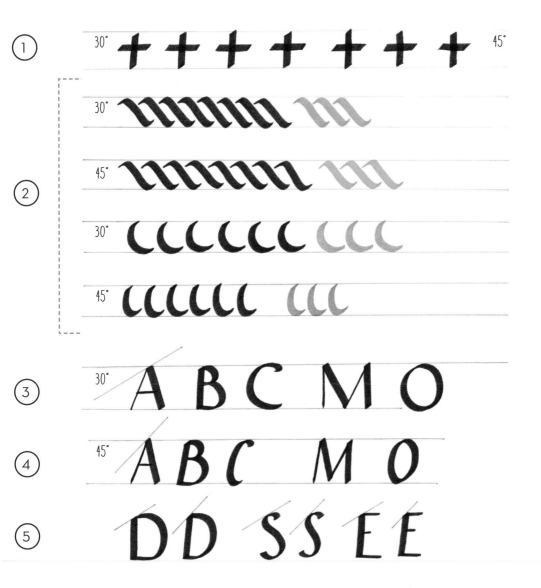

Exercises Using a Flexible Nib

A pen with a flexible nib works completely differently from one with a broad-edge nib. The breadth of the strokes, which a broad-edge nib makes using the angle of the pen, is now achieved with the pressure exerted on the point of the nib: with greater pressure, the stroke will be thicker, and relieving pressure, the stroke will be thinner. These are used with a pen holder. To fill a flexible nib with ink, simply dip the nib into a bottle of ink up to the small hole and remove excess ink by lightly tapping the nib on the edge of the bottle. For English cursive, the most suitable nib is an elbow nib, which facilitates the slope of the writing.

The same principle applies to brush tips, which will be discussed further on.

Using this type of nib also takes a good deal of practice to learn to use it correctly.

The slope of the letters in English cursive is very pronounced, 55–60 degrees (traditionally 55 degrees).

What you need

pencil and eraser – ruler – 30°-60°-90° triangle – pointed nibs and pen holder – elbow nibs – black ink – fine brush pens

FLEXIBLE NIBS are readily available in fine art supply stores; elbow nibs are mainly used to write English cursive, to keep the angle of the pen constant.

1. To get started, try this exercise: With a pointed nib, draw a series of wavy strokes, first placing a very light pressure on the tip and gradually increasing the pressure. Remember that the nib must be full. Dip the nib into enough ink, but not too much, so you neither run out of ink in the middle of a stroke nor stain the paper with excess ink droplets.
2. Now draw some guidelines and a wavy zigzag, alternating the pressure of the nib in order to produce a regular pattern of thin and thick strokes.
 Try the same exercise, making a more rigid zigzag.

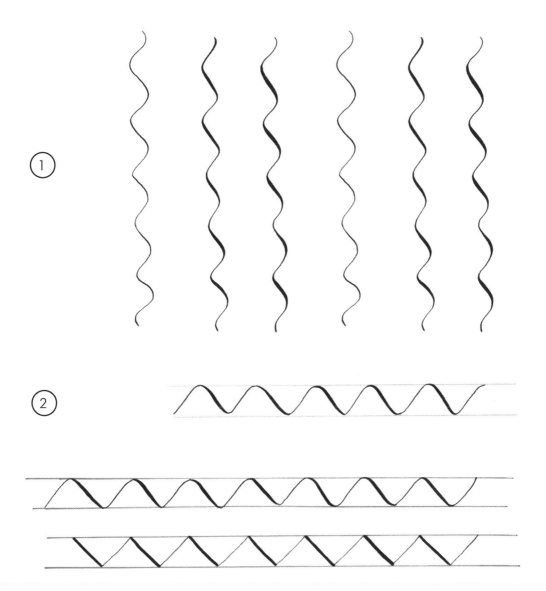

1. You probably noticed that controlling the pressure on the pen requires a certain amount of concentration. By varying the pressure, it is possible to obtain very different results in the weight of the letters. You can decide on the effects you would like to achieve at any point during writing.

2. Now prepare a sheet of paper for exercises: draw some guidelines—for English cursive—and using the 30°-60°-90° triangle, mark a series of pencil strokes on them at intervals of ¼ inch (2–3 cm) at a 60-degree angle. This will provide the slope of your letters. Alternate a series of fine and heavy strokes with continuous spacing, adding pressure so that the difference in thicknesses is evident. Continue making a very narrow zigzag combining thicker strokes with thin ones.

3. Continue with a series of regular strokes, referencing the basic features of the English alphabet. Pay attention to the heights of ascenders and descenders, as well as the spacing.

The strokes shown here are inspired by those of the large, decorative capital letters of English cursive.

1. Filling the nib with ink, try tracing the strokes several times so that they are as similar to each other as possible. Examine the width of the curves, which provide the starting and the arrival points of the scrolls. These must be drawn with confidence.
2. Repeat the same exercise, this time with a medium-point marker: note the different writing speeds and effects.

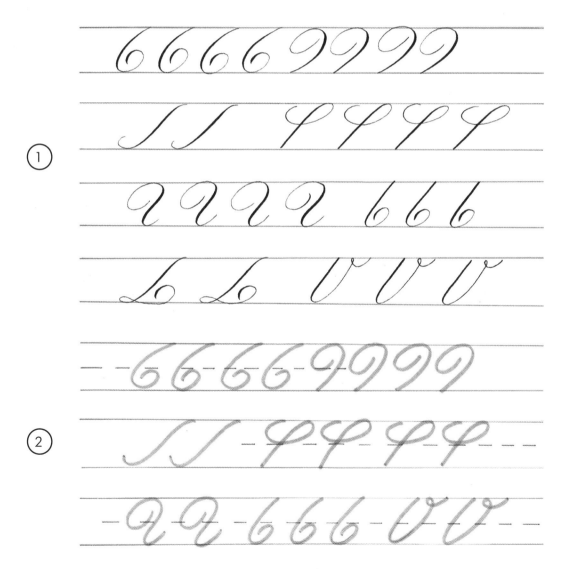

Brush Pen Exercises

As we've touched on, brush calligraphy is a highly modern, current style of lettering, executed using brush-tip pens. While it is much beloved and used in the most dynamic projects due to the immediacy of the strokes, it still requires some preparation.

As with English cursive, the thickness of a stroke depends on the pressure of one's hand on the pen, so you will have to practice a great deal. A brush tip, which is more flexible than a metal nib, actually requires more control, despite the final effect being very free.

Recall that a brush pen must never be perpendicular to the writing paper: it is best to keep an inclination of 45 degrees.

What you need

pencil and eraser – ruler – brush pen set (Pentel, Tombow) – fine brush-tip markers (Sign Pen by Pentel)

1. Draw guidelines with plenty of space between them. With a brush pen, make parallel strokes from fine to broad. Position the tip laterally, making sure to keep the widths of the strokes constant. Every now and then, make a few zigzags to loosen your hand.

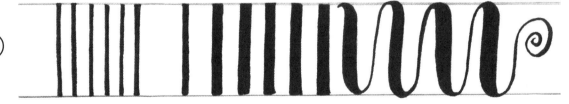

2. Draw a zigzag with strokes that are regularly distributed in width. Train yourself to make thinner strokes. In your first attempts, the transition between a thick and a thin stroke can be made easier by stopping the movement of your hand for a moment in order to relieve the pressure on the tip.

3. Draw a very narrow zigzag where the breadth of the strokes is reduced.

4. Once again, draw a corkscrew shape, maintaining a consistent rhythm, slope, and breadth of stroke.

5. With the tip of the brush, practice drawing small triangular markings, resting the tip of the brush on the paper and gradually relieving pressure to obtain the pointed shape.

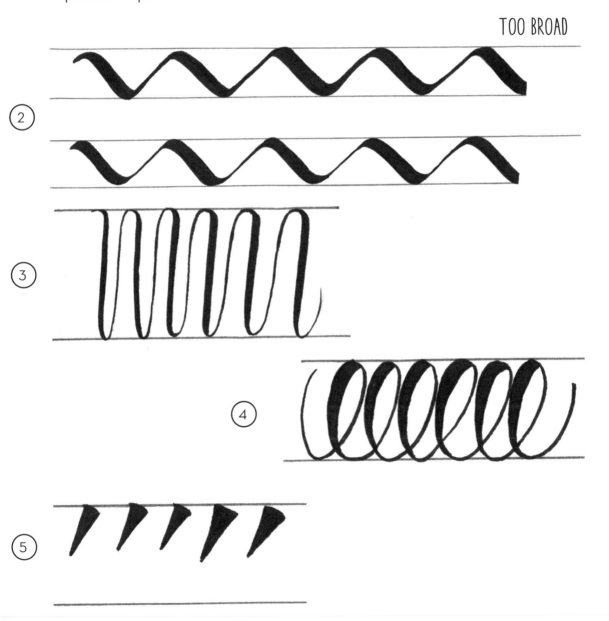

TOO BROAD

1. Draw a series of thick and thin oblique strokes at a 45-degree angle by resting the pen on the paper and pulling from left to right, then vice versa.
2. Now draw a series of curved strokes, moving gradually from broad to thin strokes. These are especially characteristic of chancery. Continue to practice until your strokes are smooth and confident.

Brush pens are also very fun because they offer a great range of colors and points, from hair-thin to very thick. You can enjoy mixing and blending them, using them for various effects in whatever way your creativity calls you to do, now aided by the technique you have acquired with practice.

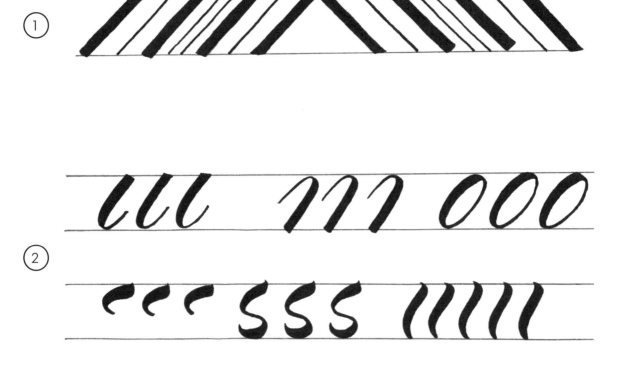

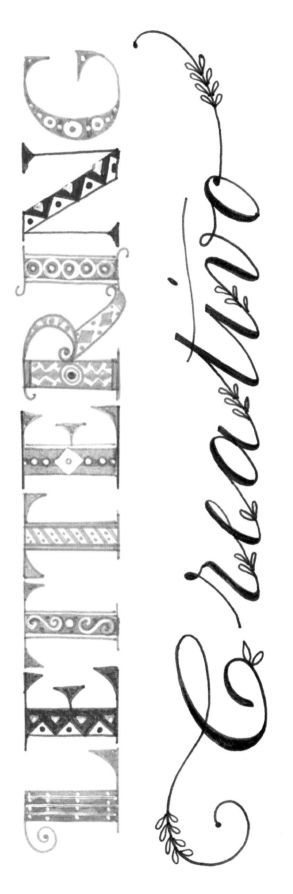

LETTERING

Creative

Laura Toffaletti was born in Verona and today she lives and works there, facts that she is very, very happy with. Since earning a degree in scenography and sculpture at the Academy of Fine Arts in her city, she has been working in her studio painting textiles, creating decorative panels, curtains, fabric furnishings, clothing, and paintings. As an illustrator, she has collaborated and continues to collaborate with numerous publishers (Demetra, Giunti, La Scuola, Arsenale, and others), drawing manuals, storybooks, children's books for early reading, handwritten recipe books, greeting cards, calendars, travel notebooks, cover art for CDs, and much more. As someone who has always been passionate about strokes, symbols, and characters, she found the Italian Calligraphic Association in 1994 and has since cultivated the study of this art alongside her work as an illustrator, thanks to the teaching of Italian and foreign calligraphy masters. She especially loves the informal elements of writing and prefers expressive forms of lettering. She exhibits this in her work by overlapping and arranging texts and images, in the belief that the more hidden the words, the greater the desire to read them becomes. She regularly teaches calligraphy courses in Verona at Fabriano Boutique, Office Store and other locations. She has published the calligraphy manuals *L'arte di scrivere bello* and *Calligrafia. Esercizi di bella calligrafia in carattere* for Edizioni Demetra and Edizioni del Baldo. In 2018, she published the manual *L'arte della calligrafia: Tecniche ed esercizi di scrittura* for White Star. In 2010, she created various texts for the film *Letters to Juliet* from Summit Entertainment, with Vanessa Redgrave and Franco Nero. These include the letter from a fifteen-year-old American teenager written to Juliet Capulet. The discovery of this letter years after it was written introduces the main plot of the film.

BIBLIOGRAPHY

Hermann Zapf, "Classical Typography in the Computer Age," Oak Knoll Press, 1991 • Martin Andersch, "Symbols, Signs and Letters," Design Press, 1989 • Salvatore Gregorietti and Emilia Vassale, "La forma della scrittura," Feltrinelli, 1988 • Giovanni De Faccio, Anna Ronchi, and James Clough, "La calligrafia," Vinciana Editrice, 2011 • Judy Martin, "The Complete Guide to Calligraphy," Phaidon Press, 1992 • Eric Hebborn, "Italico per italiani," Angelo Colla Editore, 2004 • David Harris, "The Calligrapher's Bible," Barrons Educational, 2003 • Mary Noble and Janet Mehigan, "The Calligrapher's Companion," Thunder Bay Press, 1997 • Vivien Lunniss, "Complete Guide to Calligraphy," Search Press Ltd, 2015 • Luca Barcellona, "Take Your Pleasure Seriously," Lazy Dog Press, 2012 • Edward Johnston, "Writing & Illuminating & Lettering," D&B Books, 2016 • Gaye Godfrey-Nicholls, "Mastering Calligraphy," Chronicle Books, 2013 • Andrew Robinson, "Writing and Script: A Very Short Introduction," OUP Oxford, Kindle Edition, 2017 • Massin, "Letter and Image," Studio Vista, 1970 • Bruno Munari, "Fantasia," Editori Laterza, 2017 • Steven Heller and Lita Talarico, "Typography Sketch Books," L'Ippocampo, London, 2012 • Laura Toffaletti, "L'arte della Calligrafia," Edizioni White Star, 2018 • Gabri Joy Kirkendall and Laura Lavander, "Creative Lettering and Beyond," Walter Foster Publishing, 2014 • Betty Soldi, "Inkspired: Creating Calligraphy," Kyle Books, 2017.

PHOTO CREDITS

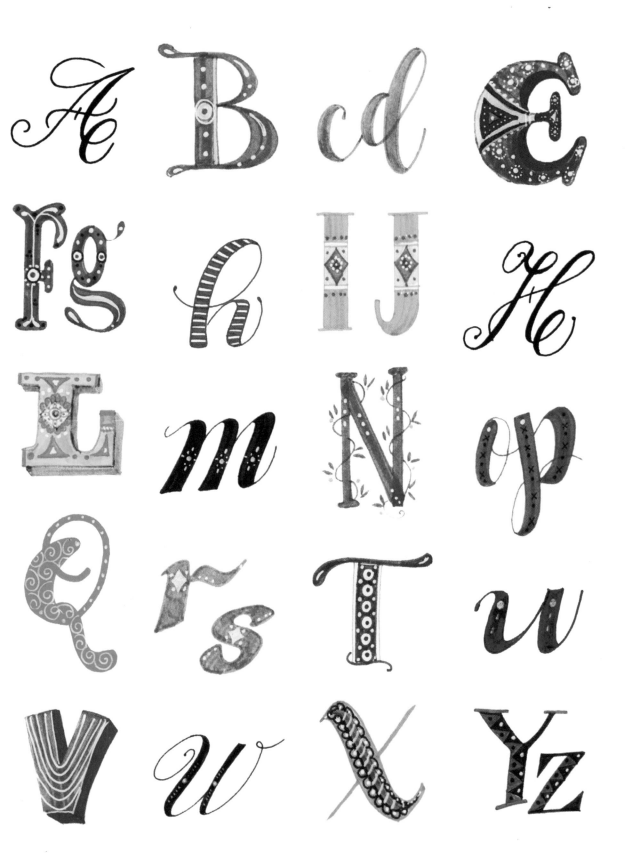